*T*HEN GATHER A WREATH FROM
THE GARDEN BOWERS,
AND TELL THE WISH OF THY HEART
IN FLOWERS.

—PERCIVAL,
AS QUOTED IN
WEEDS AND WILDFLOWERS
BY LADY WILKINSON, 1858

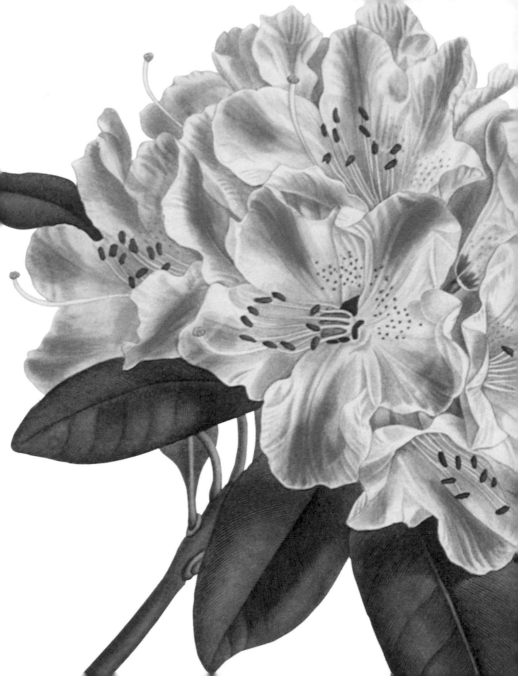

WOMEN of FLOWERS

A TRIBUTE TO VICTORIAN WOMEN ILLUSTRATORS

welcome
BOOKS

NEW YORK • SAN FRANCISCO

First published in 1996 by Stewart, Tabori & Chang
115 West 18th Street, New York, NY 10011

Published in 2005 by Welcome Books®
An imprint of Welcome Enterprises, Inc.
6 West 18th Street
New York, NY 10011
(212) 989-3200; Fax (212) 989-3205
www.welcomebooks.com

Distributed to the trade in the U.S. and Canada by
Andrews McMeel Distribution Services
U.S. Order Department and Customer Service Toll-free: (800) 943-9839
U.S. Orders-only Fax: (800) 943-9831
PUBNET S&S San Number: 200-2442
Canada Orders Toll-free: (800) 268-3216
Canada Order-only Fax: (888) 849-8151

Library of Congress Cataloguing-in-Publication Data on file.

Printed in Singapore
2 4 6 8 10 9 7 5 3 1

Jacket Design: Gregory Wakabayashi
Editorial Assistance: Alexandra Childs, Enid Stubin
Design Assistance: Melanie Random, Kathryn Shaw
Production: Christopher Young

PAGE 1: LADY AS A DAFFODIL BY JEAN GRANDVILLE; PAGE 2–3: RHODODENDRON BY MRS. AUGUSTA INNES BAKER WITHERS;
PAGE 5: MAGNOLIA BY HENRIETTA MARIA MORIARTY; PAGE 6: *HUNTLEYA MELEAGRIS* BY MRS. AUGUSTA INNES BAKER WITHERS;
PAGE 8: *AQUILEGIA* BY MRS. AUGUSTA INNES BAKER WITHERS; PAGE 9: FLORAL DESIGN CREATED BY MARY TIEGREEN; PAGE 10: BUNCH
OF PANSIES BY MRS. CLARISSA W. MUNGER BADGER; PAGE 64–65: *DIANTHUS* BY MRS. AUGUSTA INNES BAKER WITHERS; PAGE 96: PORTRAIT
OF LADY THISTLETON DYER COURTESY OF THE ROYAL BOTANIC GARDENS, KEW; PAGE 121: PORTRAIT OF JANE LOUDEN COURTESY OF
THE ROYAL BOTANIC GARDENS, KEW; PAGE 137: PHOTOGRAPH OF MARGARET MEE COURTESY AP/WIDE WORLD PHOTOS;
PAGE 152: PORTAIT OF CLARA MARIA POPE COURTESY OF PHILIP WILSON PUBLISHERS, LONDON; PAGE 157: PORTRAIT OF ANNE PRATT
COURTESY OF PHILIP WILSON PUBLISHERS, LONDON; PAGE 165: PORTRAIT OF MATILDA SMITH COURTESY OF THE ROYAL BOTANIC
GARDENS, KEW; PAGE 188: PORTRAIT OF ELIZABETH TWINING COURTESY OF ORLEANS HOUSE GALLERY, TWICKINGHAM LIBRARY.

TABLE of CONTENTS

7 · AUTHOR'S NOTE

11 · INTRODUCTION

66 · MRS. CLARISSA W. MUNGER BADGER

73 · ELIZABETH BLACKWELL

77 · PRISCILLA SUSAN BURY

80 · AGNES CATLOW

86 · SUSAN FENIMORE COOPER

91 · MISS S. A. DRAKE

96 · LADY HARRIET ANNE THISELTON DYER

102 · ELSIE KATHERINE DYKES

110 · MARY EMILY EATON

114 · NATHALIE D'ESMENARD

116 · MARY P. HARRISON

118 · HENRIETTE GEERTRUIDA KNIP

120 · JANE WEBB LOUDON

130 · THE MISSES MAUND

137 · MARGARET MEE

140 · MARIA SIBYLLA MERIAN

146 · HENRIETTA MARIA MORIARITY

151 · MARY MOSER

152 · CLARA MARIA POPE

157 · ANNE PRATT

165 · MATILDA SMITH

169 · CHARLOTTE CAROLINE SOWERBY

170 · MISS JANE TAYLOR

175 · EMMA HOMAN THAYER

178 · LOUISA ANNE MEREDITH TWAMLEY

188 · ELIZABETH TWINING

194 · PRISCILLA WAKEFIELD

196 · LADY CAROLINE CATHERINE WILKINSON

200 · MRS. E. W. WIRT

204 · MRS. AUGUSTA INNES BAKER WITHERS

214 · ACKNOWLEDGMENTS

216 · BIBLIOGRAPHY

218 · CATALOGS

219 · LANGUAGE OF FLOWERS BOOKS

220 · BIOGRAPHY CREDITS

222 · INDEX

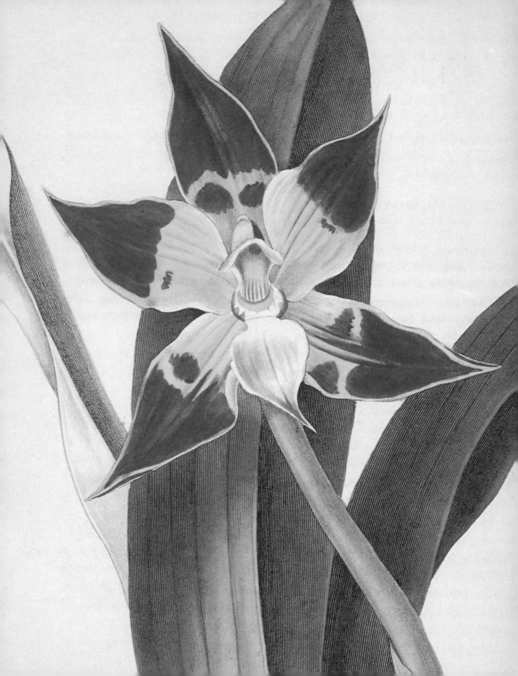

❧ AUTHOR'S NOTE ❧

This book does not attempt to be a comprehensive history of botanical art or a thorough critique of artists' work. Instead, it shows that in the eighteenth and nineteenth centuries many women were creating botanical illustrations and writing about botany and horticulture, though they were rarely given any credit for their work. The famous periodicals of the times—Maund's *Botanic Garden* and *Curtis's Botanical Magazine*, to name two—employed many women as artists, colorists, and illustrators, and the efforts of these women account, in part, for the lasting success of these works.

Yet other than a few noted exceptions—Clara Pope, Priscilla Susan Bury, Maria Sibylla Merian—Victorian women who created botanical art are seldom exhibited. Their work, as can be seen in this book, was stunning and has not faded in the past two hundred years. Though Matilda Smith's illustrations appeared in numerous periodicals and the Maund sisters were responsible for many of the gorgeous drawings in the *Botanic Garden*, their work is never shown. The fine illustrations of Mrs. Jane Loudon and Elizabeth Twining are rarely seen. In America, the excellent work of Mrs. C. W. Munger Badger and Emma Homan Thayer are likewise seldom shown. The list goes on.

The omission of the efforts of these artists obviously had its roots in Victorian attitudes toward women, which is why many of the horticultural books written or illustrated by women during that time were published anonymously. Unfortunately, the authorities on botanical art who published landmark books in 1938 and 1957 both wrote scathing comments about women's talents in botanical art (when they bothered to mention women at all). This combination of neglect and dismissal certainly did not help bring credit to these women artists.

Ninety percent of the material reproduced in this book comes from books in my own library, gathered over a period of almost thirty years. (All editions cited in the text are from my own collection, although other editions of these works may exist from different years.) Many of these glorious floral portraits have never been published in book form. I have tried to remedy this situation and chronicle how and why women's contributions were ignored. The biographies of the women discussed in this book are as complete as possible, given the fact that these artists worked in virtual obscurity and information about their lives was difficult, if not impossible, to unearth.

This book represents perhaps the first time these mostly anonymous women artists are receiving credit for their contributions to the science and art of botanical illustration—an arena dominated by men for hundreds of years.

These artists represent only a selection of their kind. There were other women illustrators of flower works who deserve to be mentioned, such as E. V. Boyle, Marianne North, Madame Vincent, and others, but space allowed only so many.

May you enjoy the liberation of these women's talents as I have enjoyed researching the women of flowers.

—Jack Kramer
March 1996

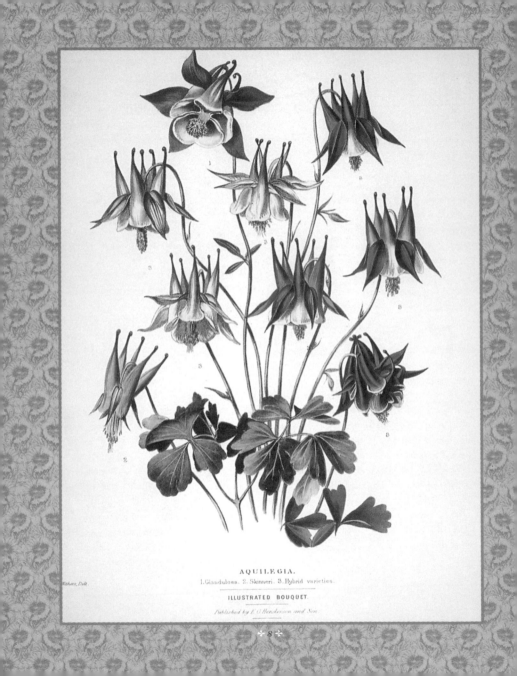

AQUILEGIA.

1. Glandulosa. 2. Skinneri. 3. Hybrid varieties.

ILLUSTRATED BOUQUET.

Published by E.G.Henderson and Son.

A PRECIOUS, MOULDERING PLEASURE 'TIS
　　TO MEET AN ANTIQUE BOOK,
IN JUST THE DRESS HIS CENTURY WORE;
　　A PRIVILEGE, I THINK,

HIS VENERABLE HAND TO TAKE,
　　AND WARMING IN OUR OWN,
A PASSAGE BACK, OR TWO, TO MAKE
　　TO TIMES WHEN HE WAS YOUNG.

OLD VOLUMES SHAKE THEIR VELLUM HEADS
　　AND TANTALIZE, JUST SO.

—EMILY DICKINSON, "IN A LIBRARY"

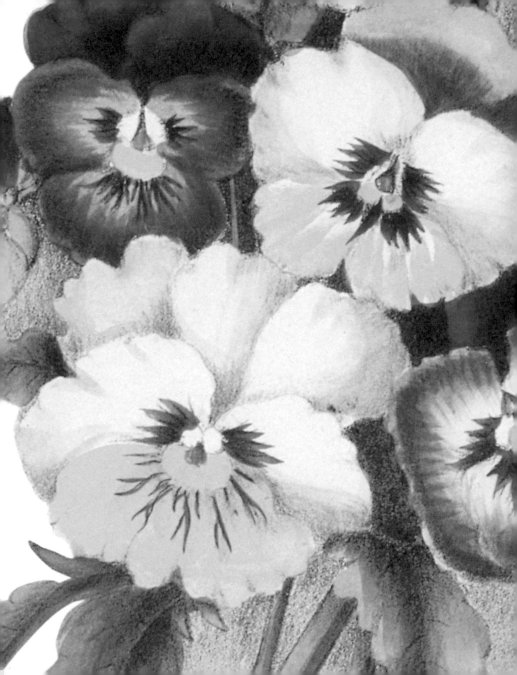

INTRODUCTION

SHE WAS STANDING INSIDE
THE SECRET GARDEN
IT WAS THE SWEETEST, MOST
MYSTERIOUS-LOOKING PLACE ANYONE COULD
IMAGINE AND SHE
FELT SHE HAD FOUND A WORLD
ALL HER OWN.
—FRANCES HODGSON BURNETT,
THE SECRET GARDEN

THERE IS A GARDEN IN HER FACE,
WHERE ROSES AND WHITE LILIES GROW;
A HEAV'NLY PARADISE IS THAT PLACE
WHEREIN ALL PLEASANT FRUITS DO GROW.

—THOMAS CAMPION

*D*uring the Golden Age of botanical art, Victorian women discovered a language, a science, and an artistic outlet to express their creativity, ingenuity, skill, and intelligence. Many of the floral books with color plates that command huge prices at auction today were rendered by gifted women during the period that began in the early 1700s and continued until the early 1900s.

While George Ehret, Pierre Joseph Redouté, and other male artists of this period were critically acclaimed, female artists worked in virtual obscurity. In fact, this book represents the first time that the work of talented artists such as Susan Fenimore Cooper, Elizabeth Twining, Sarah Lee, Matilda Smith, the Maund sisters, Char-

OPPOSITE: LADY AS A DAHLIA BY JEAN GRANDVILLE
ABOVE: FIG MARIGOLD BY ELIZABETH TWINING

OF ALL THE VARIED OBJECTS OF CREATION THERE IS, PROBABLY, NO PORTION THAT AFFORDS SO MUCH GRATIFICATION AND DELIGHT TO MANKIND AS PLANTS. . . .

—ELIZABETH TWINING, *ILLUSTRATIONS OF THE NATURAL ORDER OF PLANTS WITH GROUPS AND DESCRIPTIONS,* 1868

lotte Caroline Sowerby, Lady Wilkinson, Louisa Anne Twamley, Elsie Katherine Dykes, Henrietta Moriarty, Mrs. C. W. Badger, and Emma Homan Thayer has been fully acknowledged. In their own lifetime, these women were generally either ignored or denigrated by critics.

Wilfred Blunt in his classic *The Art of Botanical Illustration* (1950, revised 1994) and Dunthorne's *Great Flower and Fruit Books: 1700–1900* (published 1938) failed to credit or acknowledge the contributions of many women artists. On the rare occasions when a woman was acknowledged, her work was often trivialized. Henrietta Moriarty published *Fifty Greenhouse Plants, or The Viridarium* in 1803 with exceptional color plates

that critics pronounced too good to be done by the hand of a woman. In the 1917 edition of *Journal of Botany*, Robert Hardwicke accused her of plagiarizing the work of Samuel Curtis. He wrote: "Although Mrs. Moriarty speaks in her dedication of 'the time spent in executing this work' and, in the preface, of having 'delineated' the plants, the plates have in almost every case been adapted with slight alteration and no sort of acknowledgment from *Curtis's Botanical Magazine.* I have not checked each one, but have compared a sufficient number to warrant this conclusion."

Ironically, even though very few female artists or botanists achieved the recognition they deserved, the popularity of botanical art was driven mostly by the enthusiasm of women. The gentle Eng-

lishwoman, who had a traditional love of plants, became fascinated with exotic specimens of flowers and plants recovered from faraway places and thus furthered an industry of exploration by adventurous men who traveled the world in search of new plant life. Financed by the nobility and upper classes, these horticultural excursions journeyed to North and South America, Australia, the East and West Indies, South Africa, South New Wales, Japan, Italy, Spain, Portugal, and other countries and returned to England with seeds and seedlings. Because live plants often did not survive the rigors of travel, botanical artists joined these expeditions so that plants could be accurately recorded. Men such as George Ehret, Frances Bauer, and James Sowerby and a host of other talented artists and draftsmen were hired.

Of course, women were not included in such journeys of exploration even though there were certainly a few who were willing to participate.

Maria Sibylla Merian, for example, was schooled in painting and engraving in the early 1650s by her father, a Dutch painter. As a child, she collected caterpillars, sparking a lifelong fascination with entomology. Eventually, she abandoned her husband and took her children to Surinam to study insects, an adventure that would result in the 1705 publication of her landmark three-volume *Metamorphosis Insectorum Surinamensium.* Her drawings depicted insects and their host plants, establishing a technique other artists would later imitate.

DAFFODIL.

Narcissus Pseudo-narcissus

London: Published by John Van Voorst, 1858

THE SIMPLE DAFFODIL WAS A FAVORITE FLOWER DURING VICTORIAN TIMES, AND ITS POPULARITY HAS NOT WANED. THIS LOVELY EXAMPLE IS FROM LADY WILKINSON'S *WEEDS AND WILDFLOWERS.*

✿ THE FLOWERING OF BOTANY ✿

Artists did not begin drawing plants and flowers for decoration; their primary purpose was identification for the collection and use of plants and herbs for apothecaries, physicians, and people who couldn't afford doctors' fees. These herbals were also popular reference works for choosing plants for cooking, making natural dyes, and other household uses. In the thirteenth century, flowers began appearing as decorative elements, as epitomized by the paintings of Giotto. Herbals were still being produced, and the style of illustration was becoming more natural, more botanically correct. The most famous English herbal was produced in 1597 by John Gerard, the keeper of Lord Burghley's gardens.

Many other herbals appeared in various countries around the world. Slowly, plants began to be cultivated for their appearance alone, and flower books celebrating the sheer beauty of flowers were published. The watercolors of Albrecht Dürer, with their minute attention to detail and botanical accuracy, were probably the first botanical-style works intended as art rather than for identification or scientific purposes.

The formal science of identifying plants was developed by Carl Linnaeus, who created a nomenclature for plants and developed the science of botany. First expounded in his *Systema Naturae,* published in Holland in 1735, Linnaeus's binomial system of plant classification, based on the sexual parts of flowers, gave a generic and a species name to every plant and animal. In *Species Plantarum* (1753), considered the first great classification of plants, Linnaeus named every plant known to him. The binomial system became the established method for the identification of plants and animals, a compendium of all living things, and is still in worldwide use today. Linnaeus did more to further the study of botany than any other person, and during his lifetime, his work generated enormous interest in the scientific study of plants.

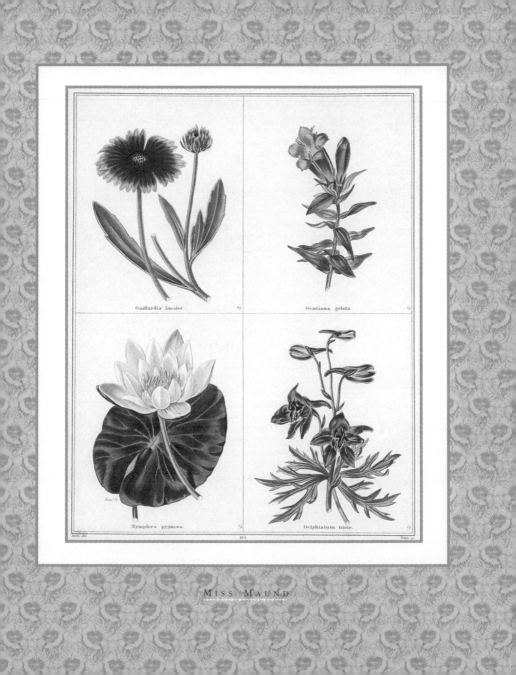

Gaillardia bicolor.

Gentiana gelida.

Nymphæa pygmæa.

Delphinium triste.

A BOOK ON BOTANY WHICH MIGHT READ LIKE ANY OTHER WAS DEMANDED, BUT REFLECTION SOON SHOWED THIS WAS IMPRACTICABLE. THE NUMEROUS CHARACTER, THE UNCERTAINTY AND EXTENT OF BOTANICAL NOMENCLATURE, THE JARGON THAT IT OFFERS OF ANGLICIZED LATIN WORDS, AND DELIGHTFUL AS THE SUBJECT MAY BE TO THOSE WHO, WITH THE OBJECTS BEFORE THEM, COME TO TASK ARMED WITH DISSECTING INSTRUMENTS AND MICROSCOPES, AT PRESENT THE LOVELIEST WORKS OF GOD ARE OBSCURED BY THE WEARYING DETAILS TO THOSE WHO HAVE NEITHER THE TIME NOR INCLINATION FOR SCIENCE. AN ENDEAVOR THEREFORE HAS BEEN MADE TO GIVE AN IDEA OF THE SIZE, BEAUTY, USES, AND THE INFLUENCE OF VEGETATION IN GENERAL; RATHER THAN TO DESCRIBE THE MECHANISM BY WHICH AN ALMIGHTY HAND HAS EFFECTED HIS PURPOSES.

—*TREES, PLANTS AND FLOWERS* BY MRS. SARAH LEE, FORMERLY MRS. T. E. BOWDICH, 1859

THE ILLUSTRATIONS ON THESE TWO PAGES WERE DRAWN BY JAMES ANDREWS FOR PUBLICATION IN *TREES, PLANTS AND FLOWERS* BY MRS. SARAH LEE WHO DEVOTED MANY YEARS TO POPULARIZING THE NATURAL SCIENCES THROUGH NUMEROUS BOOKS THAT SHE WROTE AND ILLUSTRATED. *TREES, PLANTS AND FLOWERS* WAS HER ATTEMPT TO UNRAVEL THE COMPLICATIONS OF BOTANY.

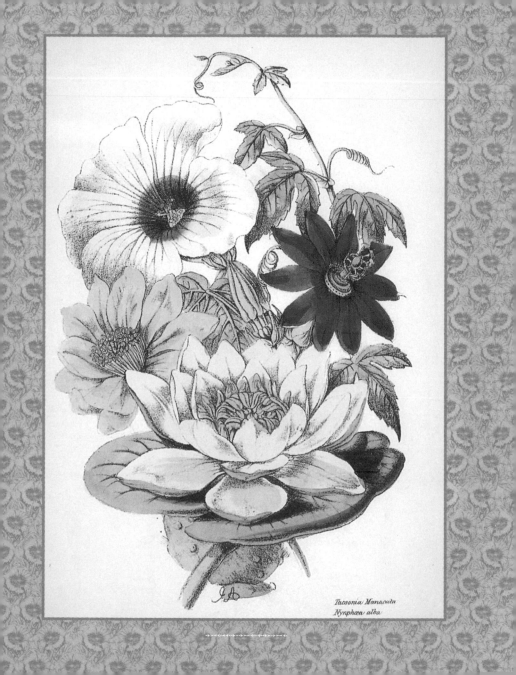

Tacsonia Manacata
Nymphæa alba

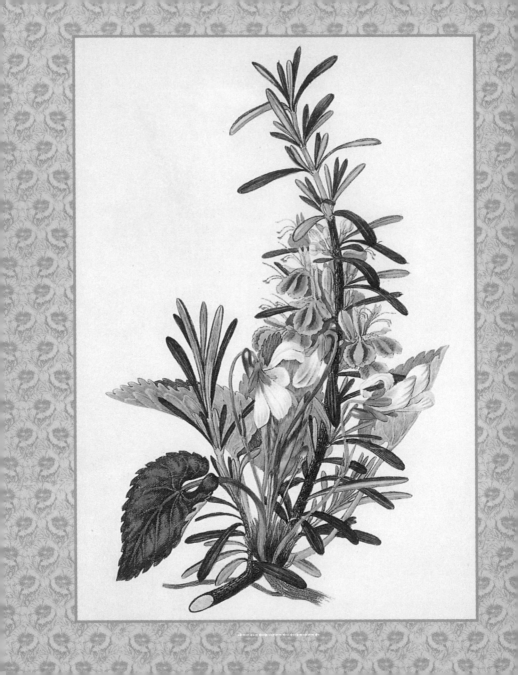

❧ A GENTEEL DIVERSION ❧

*V*ictorian society imposed many restrictions on women, confining them to hearth and home, husband and children. With no other creative outlets, the cultivation of plants and flowers, gardening, drawing, and the study of botany provided much needed diversions. Indeed, women were encouraged to study these pursuits. In the Introduction to the 1756 edition of *The Delights of Flower Painting,* the anonymous author describes the art of illustrating flowers as "a genteel, diverting and instructive study [so] that the fair sex could find amusement by the filling up of those tedious hours that would otherwise lie heavy on their hands."

The Victorians considered botany and horticulture an innocent, healthful preoccupation, an indication that God was offering his pure bounty to all. The Old Testament endorsed plants as pure, serene, and desirable. Linnaeus once claimed that Adam in his Garden was the

OPPOSITE: WILLIAM CLARK, A FINE ILLUSTRATOR, DID THE PLATES FOR REBECCA HEY'S BOOK *MORAL OF FLOWERS* (1849). THIS PLATE, ENTITLED THE ROSEMARY AND VIOLET, WAS PUBLISHED ABOVE THE CAPTION "THERE'S ROSEMARY, THAT'S FOR REMEMBRANCE."

first botanist. "There is religion in a flower," wrote the poet Bell.

Flowers signified goodness; they were "symbols of the affections, probably ever since our first parents tended theirs in the garden of God's own planting. They seem hallowed from that association, and intended, naturally, to represent pure, tender, and devoted thoughts and feelings," wrote Mrs. Sarah Josepha Hale in 1848. God created flowers that died and bloomed again and again, a miraculous event, symbolic of His omnipotence. Flower books doted on such morality, praising flowers and gardening as ways of learning and appreciating not only nature but the Supreme Being Himself. As the poet Lady Flora Hastings declared, "With holy awe I cull the opening flower, The Hand of God hath made it, and where'er / The Flow'ret blooms, there God is present also."

\mathcal{F}LOWERS ARE A DELIGHT TO EVERY ONE;
TO SOME, PERHAPS, MERELY FOR THEIR
BEAUTY AND FRAGRANCE; TO OTHERS,
INDEPENDENTLY OF THESE ACKNOWLEDGED
CHARMS, FOR THE VARIED PLEASURABLE
ASSOCIATIONS AND THOUGHTS THEY
SUGGEST. AND FOREMOST AMONGST THESE
IS THE ASSURANCE THEY AFFORD OF THE
EXUBERANT GOODNESS OF GOD.

 —REBECCA HEY,
 FROM *THE MORAL OF FLOWERS*, 1833

THE DAISY, OR *BELLIS PERENNIS*, WAS A POPULAR FLOWER DURING THE VICTORIAN ERA.
MRS. REBECCA HEY WROTE EXTENSIVELY ABOUT THE DAISY.

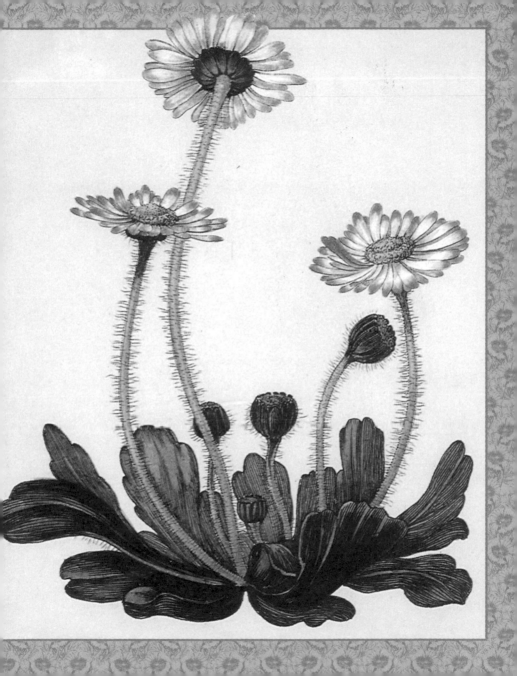

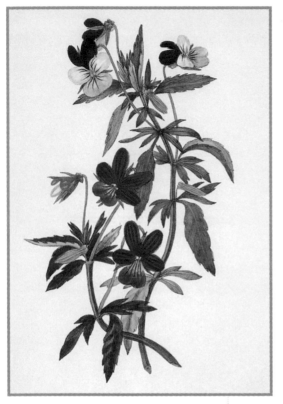

ABOVE: Known as heartsease, the pansy violet or viola had a long reign as a favorite Victorian flower. The word "pansy" is a corruption of the French word *pensée*, which may help explain Ophelia's mournful plea, "And there is pansies, that's for thoughts." OPPOSITE: The dog rose, as published in Mrs. Hey's *Moral of Flowers*.

Rebecca Hey was fanatical about flowers and their association with biblical and contemporary morals. She felt that flowers were sacred. Touched by the hand of God, flowers were symbolic of the great cycles of life and death.

To Hey, every flower had a specific meaning and she associated flowers with human characteristics such as purity and vigilance. For example, ivy symbolized love because of its entwining, clinging nature and its exquisite heart-shaped leaves. Hey also thought of flowers as harbingers of doom, goodness, or good fortune. Flowers could never be anything but pure and virtuous, and like a proper Victorian lady, Hey felt that people should behave in a like manner.

Hey's work is considered a landmark among books of poetry and flowers. Her *Moral of Flowers* (1833) reveals a natural flair for depicting the spirit of flowers, poetry, and gentle musings on sublime

subjects. Hey was a superb editor and expertly compiled the various materials that were a part of *The Moral of Flowers*. The drawings in her book were executed by William Clark, former draftsman and engraver to the London Horticultural Society. His illustrations were all drawn from nature and excellently rendered. Hey personally gathered all the plants selected for inclusion in her book.

Hey's scholarly bent and ardent love of research are apparent in *The Moral of Flowers*. While poetry forms the major portion of the book, the botanical knowledge and history of each plant discussed and drawn reveal a considerable knowledge and understanding of the field. Hey consulted with Sir J. E. Smith and Dr. Drummond to further her botanical research, and the results were a sentimental and romantic view of flowers well rooted in the science of botany.

Lady Catherine Caroline Wilkinson's *Weeds and Wildflowers: Their Uses, Leg-*ends, *and Literature* (1858), with hand-colored plates by a Mrs. Berrington, begins with a preface of mottoes and poetry by Keats, Tennyson, Shakespeare, Emerson, and others, all expounding the beauty and importance of flowers. She quotes Wordsworth: "Of humblest friends, bright creature, scorn not one—The daisy, by the shadow that it casts, Protects the lingering dew-drop from the sun." Such excerpts are illuminated with illustrations of wildflowers and highlighted with tidbits of botanical information.

Thus love of nature was elevated to a form of worship. Certain flowers were revered with religious fervor. The lily was praised for its purity. The five anthers of the passion flower came to symbolize the five wounds of Christ on the cross. The long filaments depict the crown of thorns and the calyx the glory surrounding the head of Christ.

*W*HY HAS THE BENEFICENT CREATOR SCATTERED OVER THE FACE OF THE EARTH SUCH A PROFUSION OF BEAUTIFUL FLOWERS—FLOWERS BY THE THOUSAND AND MILLION—FROM THE TINY SNOWDROP THAT GLADDENS THE CHILL SPRING OF THE NORTH, TO THE GORGEOUS MAGNOLIA THAT FLAUNTS IN THE SULTRY REGIONS OF THE TROPICS? WHY IS IT THAT EVERY LANDSCAPE HAS ITS APPROPRIATE FLOWERS, EVERY NATION ITS HOME FLOWERS? WHO DO FLOWERS ENTER AND SHED THEIR PERFUME OVER EVERY SCENE OF LIFE, FROM THE CRADLE TO THE GRAVE? WHY ARE FLOWERS MADE TO UTTER ALL VOICES OF JOY AND SORROW IN ALL VARYING SCENES, FROM THE CHAPLET THAT ADORNS THE BRIDE TO THE VOTIVE WREATH THAT BLOOMS OVER THE TOMB?

IT IS FOR NO OTHER REASON THAN THAT FLOWERS HAVE IN THEMSELVES A REAL AND NATURAL SIGNIFICANCE. THEY HAVE A POSITIVE RELATION TO MAN, HIS SENTIMENTS, PASSIONS, AND FEELINGS. THEY CORRESPOND TO ACTUAL EMOTIONS. THEY HAVE THEIR MISSION—A MISSION OF LOVE AND MERCY.

—FROM THE PREFACE TO *THE FLORAL OFFERING: A TOKEN OF AFFECTION AND ESTEEM: COMPRISING THE LANGUAGE AND POETRY OF FLOWERS* BY HENRIETTA DUMONT, 1868

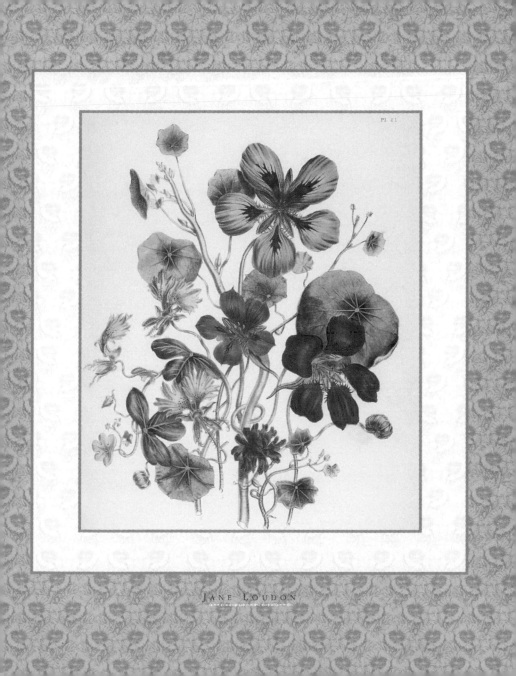

PL 21

JANE LOUDON

♣ A PASSION FOR FLOWERS ♣

Victorian women took to flowers with a passion that was extraordinary. Floral decoration appeared everywhere—on wallpaper, jewelry, embroidery, textiles, architectural motifs, porcelain, fan-leaves, and clothing. Fireplaces were adorned with all kinds of floral arrangements, dried or fresh. Drawing rooms were decorated with flowers made of paper, felt, shells, or glass. In the 1829 edition of *Flora's Dictionary*, Mrs. E. W. Wirt suggests "the aid of an *herbarium*, in which flowers are preserved by simple pressure between the leaves of an *album*. Such an *herbarium* would be an ornament to a parlor table, and would, moreover, encourage and facilitate the study of botany." In high society, floral drawing parties replaced traditional needlepoint gatherings.

The interest of royalty also helped promote horticulture. Princess Charlotte of Mecklenberg-Strelitz, the Dowager Duchess of Portland, trained her daughters in botany. Queen Charlotte and George III were devoted to flowers. The Queen liked to color engravings from botanical plates of *Erica*, rendered by the famous Franz Bauer. Many drawing books were dedicated to her. In royal households and great manor houses, flower books were prominently displayed.

This fascination with flowers reached its pinnacle when Princess Victoria assumed the throne in 1837. Kew Gardens was opened to the public early in Victoria's reign, and its new director, Sir William Jackson Hooker, expanded the gardens from eleven to more than six hundred acres so that the lower classes of London could enjoy nature's bounty. The Great Palm House of 1848, arguably the most magnificent greenhouse ever constructed, was a tribute to society's love of plants at the time. The Crystal Palace Exhibition in 1851 was the first grand exposition that brought exotic

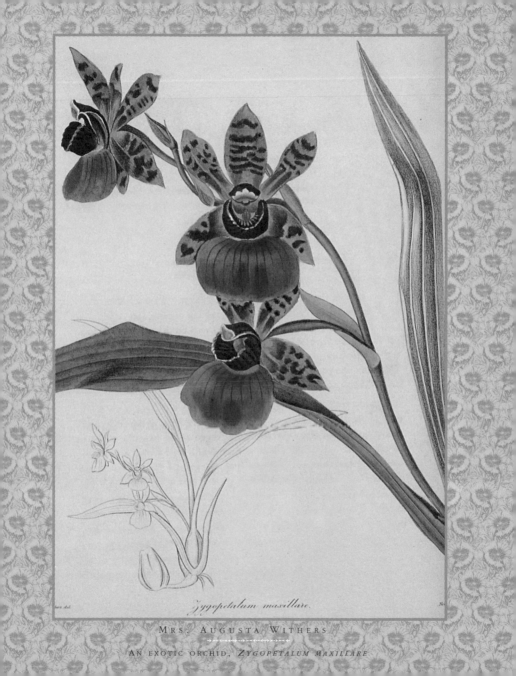

Zygopetalum maxillare.

Mrs. Augusta Withers.

An exotic orchid, *Zygopetalum maxillare*

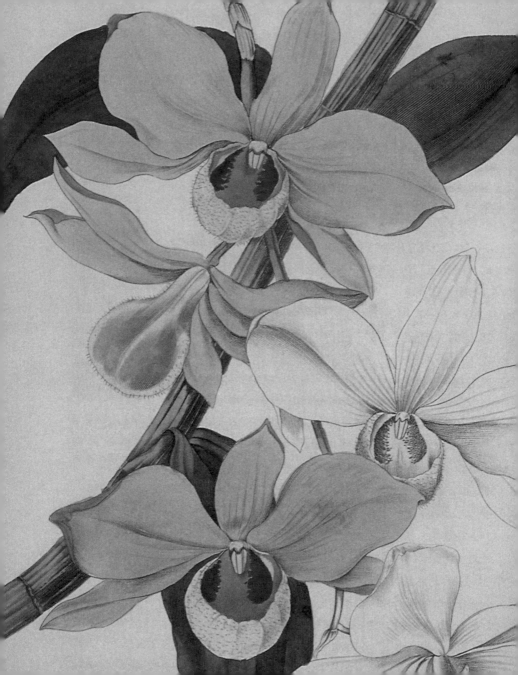

plants and flowers to the general public.

Society virtually blossomed; roses, lilacs, pansies and forget-me-nots were practically worshipped. Even the lowly hollyhock, usually the deadbeat of the floral kingdom, was wildly popular. But the most adored flower was the orchid. Coveted by the upper classes and considered as valuable and rare as precious gemstones, orchids were grown in the newly constructed greenhouses (then called stove houses), which were built on private properties as a result of advances made

during the Industrial Revolution. Inexpensive fuel and the repeal of the glass tax made greenhouses affordable to build and maintain, and no respectable estate was complete without one. The upper classes tried to outdo each other by stocking their greenhouses with orchids and other exotic plants from Java, Borneo, and all parts of South America. Orchid hunting became a lucrative business, and a map of a stand of orchids was as prized as a pirate's treasure map. During bidding at the Steven auction house in London, orchids demanded prices as high as $2,000 (in 1996 dollars).

And each orchid blooming was an excuse for a grand party.

Women (and many men) became avid gardeners. The Empress Josephine created the gardens at Malmaison in Paris. Gardeners from all over the world tended her extraordinary collection of plants, which garnered the interest of the entire populace. Redouté painted the sublime roses of Malmaison and became world-famous.

Also about this time, Humphrey Repton, a landscape artist, began designing the kind of garden we know today, as opposed to the "painter's landscapes" of Capability Brown. Repton's flowers and flower beds flowed between buildings and landscapes, which was quite new and exciting for that day. His very fashionable garden imitated the Renaissance garden with its parterres, clipped hedges, and borders of flowers.

The publication of flower books and botanical magazines exploded; more than twice as many botanical or horticultural works were published from 1800 to 1850 than during the entire previous century. The public eagerly anticipated the arrival of a new horticultural publication.

The Flower Game

HAVE A LARGE BOUQUET READY; LET EACH PERSON DRAW FROM IT A FLOWER, AND THE MEANING ATTACHED TO IT WILL TYPIFY THE FUTURE CONSORT'S CHARACTER. FOR EXAMPLE:—SAY YOUR BOUQUET FOR SPRING CONSISTS OF VIOLETS, HYACINTHS, PRIMROSES, DAISIES, HAWTHORN, DAFFODILS, THEN THE CHARACTERS WOULD BE

VIOLET, MODEST;

HYACINTH, PLAYFUL;

PRIMROSE, SIMPLE;

DAISY, AN EARLY RISER;

HAWTHORN, HOPEFUL;

DAFFODIL, DARING.

OF COURSE, THE PERSONS WHO DRAW THE FLOWERS ARE SUPPOSED TO BE IGNORANT OF THEIR MEANING; OR THEY MAY DRAW BLINDFOLDED.

IN WINTER THIS GAME MAY BE PLAYED WITH PAINTED FLOWER CARDS; PAINTING A PACK WOULD BE A PLEASANT HOME AMUSEMENT; OR DRIED FLOWERS GUMMED ON CARDS WOULD ANSWER PERFECTLY WELL. THE PLAYERS THEN DRAW A CARD INSTEAD OF A FLOWER.

—FROM *THE LANGUAGE OF FLOWERS*, ANONYMOUS,
PUBLISHED BY FREDERICK WARNE & CO., UNDATED

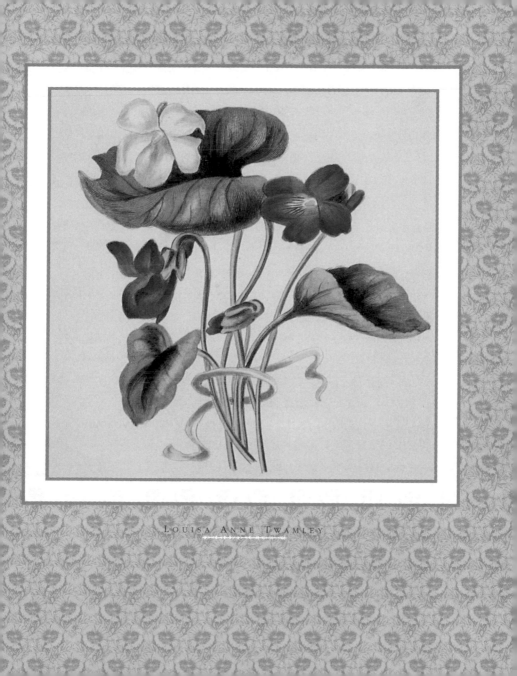

LOUISA ANNE TWAMLEY

AN ETERNAL BOOK
WHENCE I MAY COPY MANY A LOVELY SAYING
ABOUT THE LEAVES AND FLOWERS.
—JOHN KEATS,
AS QUOTED IN *WEEDS AND WILDFLOWERS* BY LADY WILKINSON

*I*n the seventeenth century, new printing processes—etched or engraved copper plates—ushered in the era of the *florilegiums* (flower books). One of the first was Pierre Vallet's *Le Jardin de Trés Christien Henri IV* in 1608. The work contained beautiful drawings gracefully done; every detail of a plant—stems, roots, flowers—was accurately rendered in vivid color.

LIKE MANY WELL-KNOWN ARTISTS OF THE TIME, GEORGE BROOKSHAW, ONE OF THE FINEST NINETEENTH-CENTURY ILLUSTRATORS, WROTE A BOOK ON HOW TO PAINT FLOWERS FOR LADIES.

flower book tradition in England as Pierre Joseph Buc'hoz and Redouté did in France.

In the eighteenth century, reading became fashionable, and a library was considered a necessary addition to any respectable Georgian mansion. There was great demand for the beautifully crafted book, especially the botanical volume, which could be left on

Vallet was unrivaled in the plant world until G. D. Ehret published *Hortus Cliffortianus* in 1737, probably the first manor-house-library flower book. In 1799 the publication of Dr. John Thornton's *Temple of Flora* made botanical art history by depicting flowers against their natural backgrounds. After Ehret's death in 1770, John Edwards continued the

a library table. A large collection of books gave the impression that the owners were rich and cultivated. Even middle-class houses included a small library. Elegant Chippendale and Sheraton bookcases and library tables became popular.

Botanical magazines,

periodicals, and books containing hand-colored plates proliferated during this century. These volumes contained scores of illustrations and employed many women to provide drawings or to color the art. For forty-four years, Matilda Smith was the artist for *Curtis's Botanical Magazine* and contributed more than 2,300 drawings.

Filling an album with watercolors and drawings of flowers was a favorite pastime for Victorian women. A personal drawing master was an essential instructor for ladies of the upper class. Henriette Geertruida Knip was instructed by her father, the still-life painter Nicolas Frederick Knip. Her brothers became landscape painters like their father, but Henriette pursued flowers. From 1802 to 1805, she studied with Gerard van Späendonck in Paris, which may account for her excellent renderings of flowers. Mary Moser was also taught by her father, a Swiss portrait painter who settled in England and taught drawing to King George III. In later life, he was one of the founding members of the Royal Academy.

Women studied flower painting and then went on to become teachers themselves. A few of the more well known female artists earned a steady living by teaching botanical art. Mademoiselle Basseporte, a favorite of Louis XV and a friend of Madame de Pompadour, became a professor of flower painting and continued working well into her nineties. Today, her illustrations are in the British Museum with those of Claude Aubriet, Gerard van Späendonck, and Redouté.

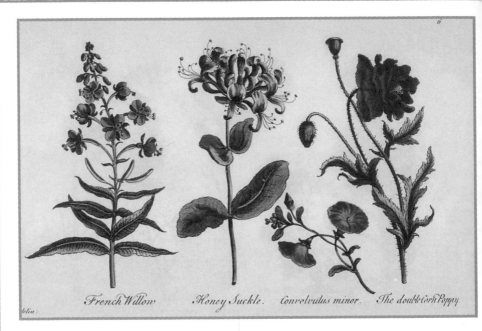

French Willow *Honey Suckle.* *Convolvulus minor.* *The double Corn Poppy*

If an art teacher's fee was beyond the means of poorer families, there were instructional books to teach the basics of flower drawing. The first edition of *The Lady's Drawing Book and Compleat Florist* was printed in 1755 and contained twenty-six plates of flowers, the first four in outline form so that the reader could finish the work in her own colors. Subsequent editions followed. *The Florist, or an Extensive and Curious Collection of Flowers for the Initiation of Young Ladies Either in Drawing Pictures or in Needlepoint* was first published in 1759 and featured sixty plates. Both books were

reprinted many times over the next decade. *Flower Painting Made Easy* (1766) contained seventy-two plates of drawings and was advertised as having "directions for coloring of flowers and painting upon silk followed by instruction for coloring plates." Great artists such as James Sowerby contributed to instructional books; his *Easy Introduction to Drawing Flowers According to Nature* (1788) became a best-seller. A demand for books on how to draw flowers emerged in the late 1700s, and scores of how-to-paint-flower volumes flowed into the mainstream culture, including as

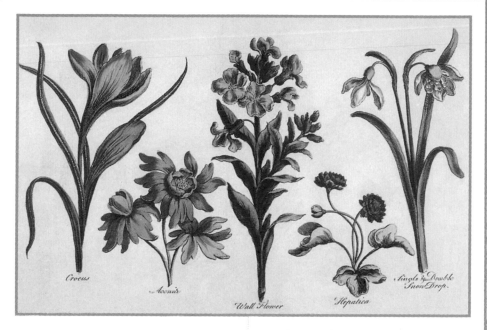

Crocus

Aconis

Wall Flower

Hepatica

Single & Double SnowDrop.

mentioned A. Heckle's *The Lady's Drawing Book and Compleat Florist.* Not only was flower painting an ecstatic pursuit, but flowers in needlepoint also abounded; indeed, the needlepoint explosion must also be considered part of the Victorians' love affair with flowers.

In 1801, Mary Lawrence published the drawing book *Sketches of Flowers from Nature,* which provided instructions for coloring the plates in the volume. The drawings were etched beautifully and hand-colored by Lawrence,

revealing a deft talent for botanical illustration. *Flower Painting for Beginners* by Ethel Nesbit included twelve studies from nature, many outlines of flowers and finished full color drawings that could be copied, along with detailed instructions. *A New Treatise on Flower Painting, or Every Lady Her Own Drawing Master* (1816) by the famous George Brookshaw, author of *Pomona Britannica,* contained lovely color illustrations and is a definitive example of how-to-draw flower books.

FOLLOWING PAGE AND ABOVE: PAGES FROM *THE LADY'S DRAWING BOOK AND COMPLEAT FLORIST* BY A. HECKLE, 1755, A FINE EXAMPLE OF A VICTORIAN BOOK ON HOW TO DRAW FLOWERS.

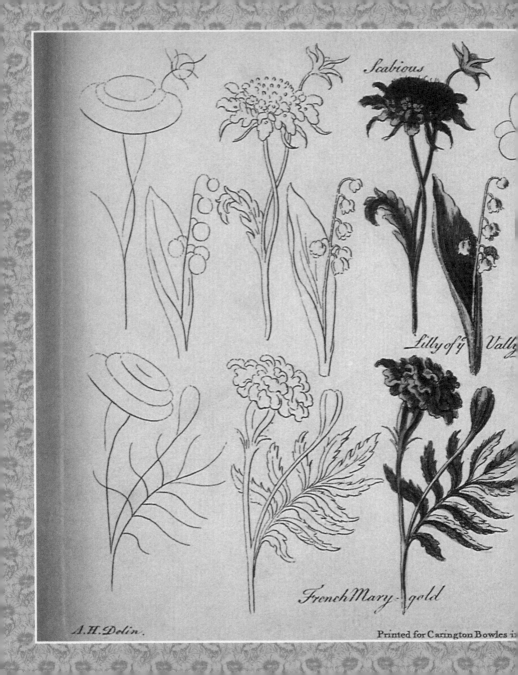

Scabious

Lilly of y Vally

French Mary-gold

A.H.Dolin.

Printed for Carington Bowles i

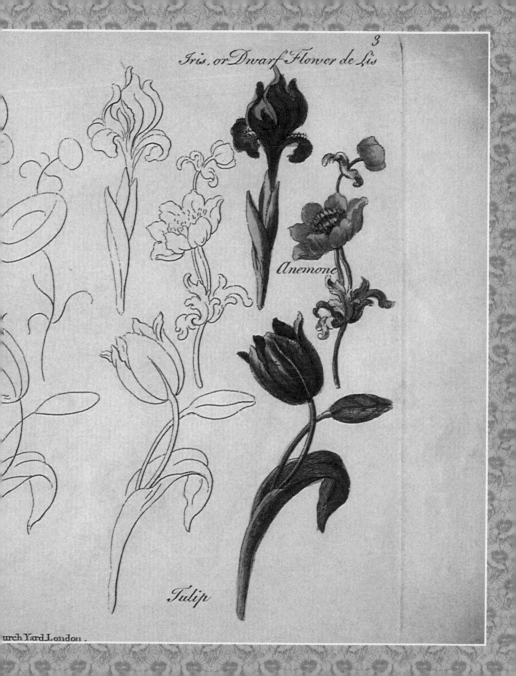

Iris, or Dwarf Flower de Lis

Anemone

Tulip

urch Yard London.

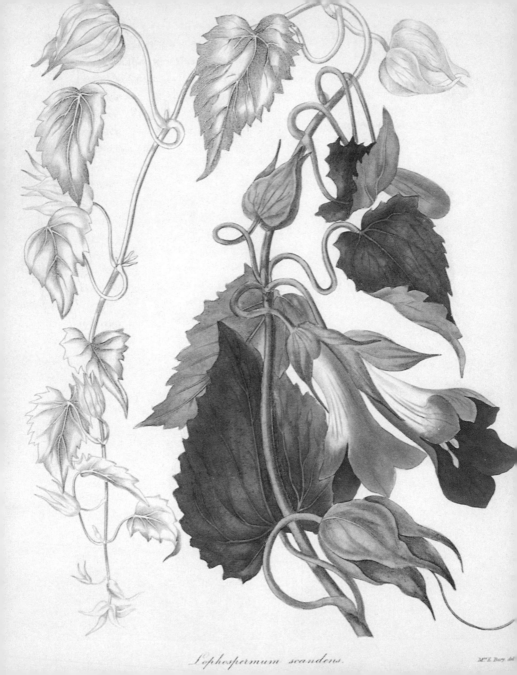

Lophospermum scandens.

*B*otany books written by and for ladies were widely published. In 1797 Maria Jacson published the instructional *Botanical Dialogues for Use in Schools*. Maria Agnes Catlow delicately illustrated three books: *Popular Field Botany* (1847), *Popular Garden Botany* (1855), and *Popular Greenhouse Botany* (1857). Her work was botanically accurate. Catherine Teresa Cookson painted Indian flora with great dexterity in her magnificent *Flowers Drawn and Painted in India* (1834-35), which even received the acclaim of Dunthorne, the expert of the early 1900s. He wrote that Cookson provided "Good examples of well-painted lithographs with delicate gray shading and very careful coloring," which was certainly a rave review for a book by a woman.

Jane Loudon published several noteworthy books on botany, promoting it as a fitting and useful endeavor for women. Her books were especially popular with women because Loudon wrote in a personal manner, discussing her own life and using simple, clear language to explain horticulture, always making sure to avoid complicated terminology. Her instructions in *Gardening for Ladies*, an excellent botanical work, went through nine printings and sold more than 20,000 copies. Loudon also contributed to the work of her husband, John Claudius Loudon, a noted writer and landscape gardener.

Priscilla Susan Bury's illustrations of lilies and amaryllis in *Selection of Hexandrian Plants* (1831) are among the most vibrant and beautiful examples of botanical art. In addition to possessing a sense of color and keen eye for flowers, Bury was an excellent writer who, in true genteel Victorian manner, continually depreciated herself by citing her flaws and inadequacies. On June 5, 1829, she wrote William Roscoe, a botanist and author of *Monandrian Plants*, that "It has been a favourite amusement with me to make a collection of *portraits* of Lilies, for which

> BLAME ME NOT LABORIOUS BAND,
> FOR THE IDLE FLOWERS I BROUGHT;
> EVERY ASTER IN MY HAND
> COMES BACK LADEN WITH THOUGHT.
> —RALPH WALDO EMERSON,
> AS QUOTED IN *WEEDS AND WILDFLOWERS*
> BY LADY WILKINSON

LEFT: *LOPHOSPERMUM SCANDENS* BY PRISCILLA SUSAN BURY.

"I have enjoyed considerable opportunities, and my friend Mr. Swainson is now endeavouring to make such arrangements as may enable me to offer them to the public. I have very faint hopes of success and sometimes think the attempt is too presumptuous to persevere in." Self-denigration was a common practice for the Victorian woman who ventured into publishing her work. Frances S. Osgood, in her preface to *The Poetry of Flowers,* allows as to how "an apology may be deemed necessary for apparent egotism, in introducing so frequently [my] own effusions, among those of a far higher order." Even Anne Pratt, a successful Victorian botanist, illustrator, and

ABOVE AND OPPOSITE: ILLUSTRATIONS FROM SHOBERL'S *LANGUAGE OF FLOWERS*, 1839.

author of numerous books, opens her *Flowers and Their Associations* (1840) with the "hopes these pages may not be unacceptable."

Compare these sentiments to those of two Englishmen who undertake similar tasks. John Ingram states in the preface to *The Language of Flowers or Flora Symbolica* (1887) that his book "will be found to be the most complete work on the subject ever published— at least in this country. I have thoroughly sifted, condensed, and augmented the productions of my predecessors, and have endeavoured to render the present volume in every respect worthy of the attention of the countless votaries which this 'science of sweet things' attracts; and, although I dare not

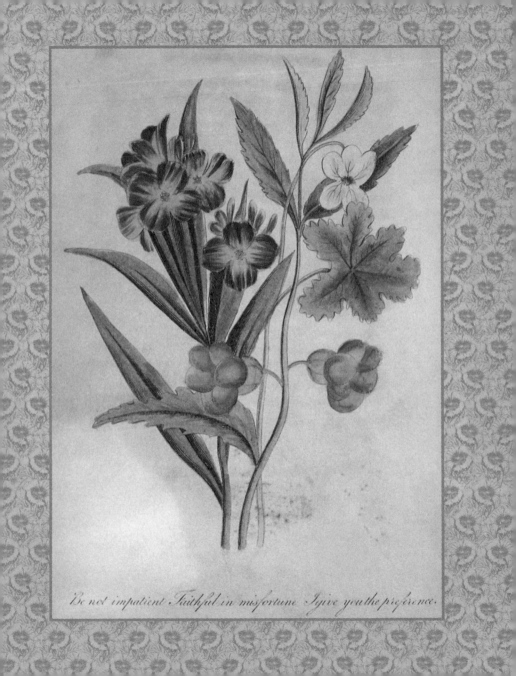

Be not impatient. Faithful in misfortune. I give you the preference.

boast that I have exhausted the subject, I may certainly affirm that followers will find little left to glean in the paths that I have traversed." Thomas Miller, author of *The Poetical Language of Flowers*, is similarly confident. "[N]or am I aware of any production in the English language on this subject which professes to be original, saving the present I have proceeded without fear, and have adapted many 'an old-world story' to the meanings of the flowers, which, I trust, will give pleasure to all my readers." Apparently, Victorian men were not nearly so reticent or self-effacing about their efforts as were their female counterparts.

From 1807 to 1848, ten volumes of *Transactions of the Horticultural Society* were issued. This society, one of the most famous horticultural groups ever created, employed female artists; the names of Augusta Withers and Miss S. A. Drake were two of several artists represented. Miss Drake's drawings also

ABOVE: FANCIFUL MAGNOLIA BY ELIZABETH TWINING. OPPOSITE: A TULIP BY ELSIE KATHERINE DYKES.

appear in John Lindley's *Ladies' Botany* (1834), which was reprinted well into the early part of the twentieth century.

Elizabeth Twining, granddaughter of the tea merchant Richard Twining, devoted most of her time to botany, so her drawings were scientifically accurate and pleasing, especially her renditions of bouquets. Twining's drawings for *Illustrations for the Natural Order of Plants* (1849-55) reveal a real flair for floral art. Her name is also sometimes attributed to drawings in Charles McIntosh's popular garden books.

Art books depicting flowers and plants were created and printed by upper-class ladies (who could pay for the printing and binding) or by artists who were supported by wealthy patrons. The publisher would solicit a group of subscribers who would agree to pay for the book in advance.

Until the advent of lithography, printing illustrated books was a long and tedious process that began with the

creation of an original illustration. The details of this image were then transferred to stone or copper, in itself a complicated and demanding procedure that required the skills of a competent artisan. Once engraved, the image was then transferred to paper. Finally, the printed image had to be hand-colored, which was, in essence, the work of an artist. For this particular job, women were hired, partly because they were known to have a "gentle hand" with color and partly (perhaps mostly) because their labor was much cheaper than that of men.

Women learned the craft of hand-coloring, and some went on to become accomplished at engraving and printing, too. Elizabeth Blackwell, for example, not only created the original images for her book, *A Curious Herbal*, she also executed the engravings and hand-colored the 500 plates. Two British artists, Mrs. Augusta Withers and Miss S. A. Drake, actually drew the plates in James Bateman's extraordinary *Orchidaceae of Mexico and Guatemala* (1837-43), but they are seldom given proper credit for their tremendous contributions. Elsie Katherine Dykes edited *Notes on the Tulip Species* after her husband died, and she provided all of the fifty-four colored plates. Yet, until recently, her husband received most of the credit for the book.

ANONYMOUS WAS A WOMAN OF FLOWERS

> LIKE THE MUSICIAN, THE PAINTER, THE POET, AND THE REST, THE TRUE LOVER OF FLOWERS IS BORN, NOT MADE.
> —CELIA THAXTER

Women wrote and published their drawings and their ideas and thoughts about flowers and gardens, but quite often they were not bold enough to put their names to their work. Thus, many of these works were published anonymously, giving credence to the adage: "Anonymous was a woman." *Floral Poesy: A Book for All Seasons*, for example, was a treatise on the mythology and symbolism of flowers, including poetry and an explanation of the floral language through vocabulary and flower dialogues. Another popular book signed Anonymous was produced in Ireland and titled *Flower Lore: The Teaching of Flowers, Historical, Legendary, and Poetical and Symbolical*. Scores of books credited anonymously followed: *The Bouquet or Lady's Flower Garden* and many, many volumes published with the title *The Language of Flowers*.

Though they were always published anonymously, the books of Maria Elizabeth Jacson added much to botanical art and the science of botany. Her works include *Botanical Dialogues* (1791), a children's primer designed for use in schools; *Botanical Lectures* (1804); *Sketches of Physiology of Vegetable Life* (1811); and the *Florist's Manual* (1816). The frontispiece of the *Florist's Manual* lists Anonymous as the author, but the end of the book is signed Maria Elizabeth Jacson, Somerset Hall, Utoxeter, Staffordshire.

Many of the floral and botanical books written or drawn by women were credited as "Drawn and Coloured by a Lady" or more simply, "By a Lady." The American, Susan Fenimore Cooper, daughter of writer James Fenimore Cooper, published a book in the early 1850s called *Rural Hours by a Lady*, about her life in upstate New York. The volume describes in great detail the flora and fauna of the region and is illustrated with beautifully rendered drawings of flowers and birds. Cooper's name does not appear anywhere in the book, although her father, "The Author of *The Deerslayer*," is featured quite prominently.

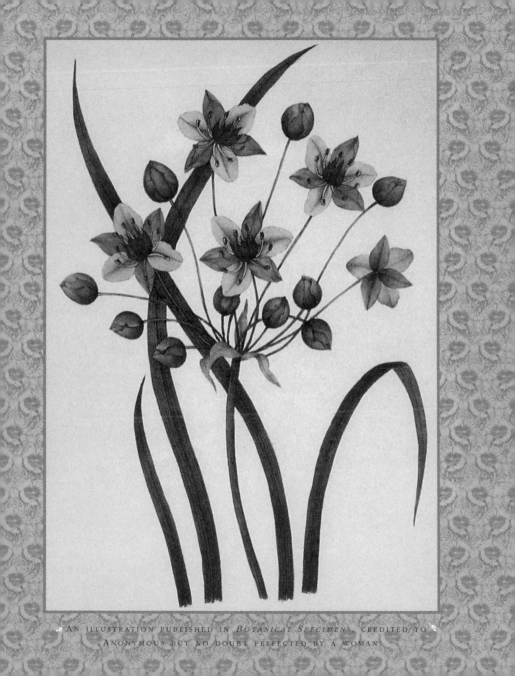

AN ILLUSTRATION PUBLISHED IN *BOTANICAL SPECIMENS*, CREDITED TO ANONYMOUS BUT NO DOUBT PERFECTED BY A WOMAN.

A SHORT SAMPLE OF SENTIMENTAL AND POETRY BOOKS

WRITTEN AND EDITED BY WOMEN OF FLOWERS

GLEANINGS FROM THE FIELD OF LIFE
BY FLORENCE BAILY (1882)

FLORA'S INTERPRETOR
BY SARAH JOSEPHA HALE (1833)

EVERY LADY HER OWN FLOWER GARDEN
BY MRS. S. O. JOHNSON (1842)

LADY'S BOOKS OF POETRY AND FLOWERS
EDITED BY LUCY HOOPER (1824)

THE LADIES WREATH, AN ILLUSTRATED MANUAL
BY LAURA GORDON MUNSON (1849)

FLORA'S LEXICON
BY CATHERINE WATERMAN (1839)

THE FLORAL OFFERING
EDITED BY FRANCES OSGOOD (1840)

THE POETRY OF FLOWERS
BY L. J. SIGOURNEY (1844)

THE LANGUAGE OF FLOWERS
BY HENRIETTA DUMONT (1868)

THE RURAL WREATH
EDITED BY LAURA GREENWOOD (1853)

In Victorian England, a lady's name was considered sacred and meant to be held in strict and pure reverence, certainly not to be used for crass, commercial purposes. Only a few women were bold enough to break with this tradition. Mrs. Edward Roscoe allowed her name to be used in *Floral Illustrations of the Seasons* in 1829. In 1833 Mrs. Hey published *The Moral of Flowers* and *Spirit of the Woods*. Mrs. Louisa Anne Twamley also wrote a book called *Romance of Nature* (1853), but these are by far exceptions to the general practice.

FRONTISPIECE FROM *FLORA DOMESTICA* BY ELIZABETH KENT, ONE OF THE MANY SENTIMENTAL FLORAL BOOKS PUBLISHED IN THE VICTORIAN ERA.

Women who actually cared about selling their books had a legitimate reason to conceal their identities. The few pioneering women who published books under their own names were treated harshly by the critics. From 1737 to 1739, Elizabeth Blackwell wrote, illustrated, and published *A Curious Herbal,* a compendium of five hundred illustrations of the plants at the Chelsea Physic Garden. While plants were indeed her passion, she published the book out of the dire financial need to free her husband from debtor's prison. Critics applauded her bravery on behalf of her husband but ignored her superb artistic merits. After her husband died in prison, Blackwell never published again.

With the publication of the five-volume work *The Flowering Plants, Grasses, Sedges and Ferns of Great Britain,* Anne Pratt, a grocer's daughter from Kent, achieved social acceptance as an artist. Her work was finely done and rendered with an excellent sense of color and composition. She displayed a beautiful hand at portraying flowers of all kinds. The British public admired Pratt's drawings, but she is given only limited credit for her many contributions to the field of

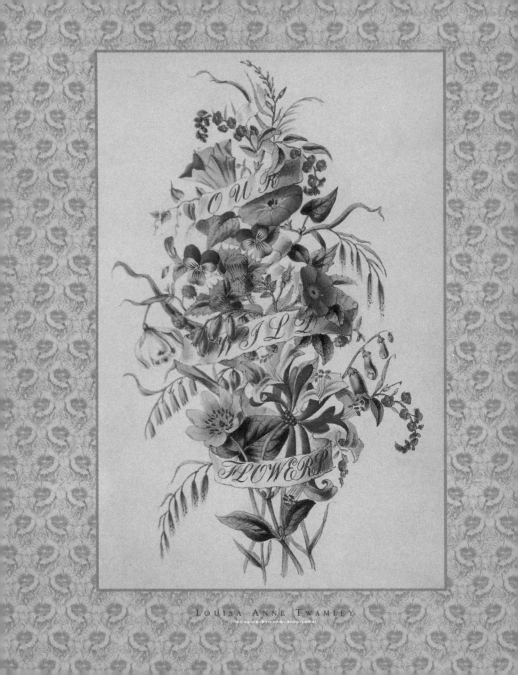

OUR WILD FLOWERS

LOUISA ANNE TWAMLEY

botanical art.

Jane Loudon wrote many books for young gardeners, encouraging them to study botany. Her daughter, Agnes Loudon, grew up to follow in the same tradition, becoming a children's book author herself. Other Victorian women illustrators used their talents to write and illustrate children's books, a more acceptable vehicle for the female artist. In 1799, Lady Charlotte Murray published *British Gardens*, a two-volume work mainly for children. It was popular and appeared again in 1808. Later editions of the work were published anonymously.

Louisa Anne Twamley, a gifted floral artist who was seldom recognized for her drawings of nature, wrote a children's book, *Our Wild Flowers* (1839 and 1842), which displayed graceful and carefully executed replicas of flowers. In

her forward to *Our Wild Flowers*, she addresses her young readers with a modesty that was typical of Victorian women. "My dear young Readers: I have no doubt you all love Flowers, for they are such beautiful things themselves, and are found in such pleasant places, and at such happy times, that you would like them, even if their bright colours and lovely forms were less gifted to delight you. But you *do* love them, as all happy young creatures who have eyes and hearts must do—as I loved them when I was a child . . . If you praise me I shall be content, and most pleased. I have not written for the learned naturalist and the stern critic; I have written for the young, the enquiring, and the kind. I have wreathed England's wild flowers for England's Children—may they approve my offerings!"

JEAN GRANDVILLE

I ONCE KNEW TWO LOVERS, WHO WERE SEVERED BY A CRUEL DESTINY. AT THE CLOSE OF A LONG SEPARATION THEY DIED, WITHOUT AGAIN SEEING ONE ANOTHER. THEY WERE NOT PERMITTED TO CORRESPOND,— BUT TO ONE OF THEM AN INGENIOUS DEVICE OCCURRED. WITHOUT EXCITING SUSPICION, THEY SENT TO EACH OTHER THE SEEDS OF THE FLOWERS WHICH THEY MUTUALLY CULTIVATED. THEY THUS KNEW, THOUGH TWO HUNDRED LEAGUES APART, THAT THEY HAD THE SAME OBJECTS OF INTEREST. AT THE SAME SEASON OF THE YEAR, AND ON THE SAME DAY, THEY SAW THE SAME FLOWERS EXPAND, AND THEY INHALED THE SAME ODORS. THIS WAS A PLEASURE—AND IT WAS THEIR ONLY PLEASURE.

—ALPHONSE KARR'S 1847 INTRODUCTION TO
 THE FLOWERS PERSONIFIED BY N. CLEAVELAND, ESQ.,
 AN AMERICAN TRANSLATION OF
 JEAN GRANDVILLE'S LES FLEURS ANIMES

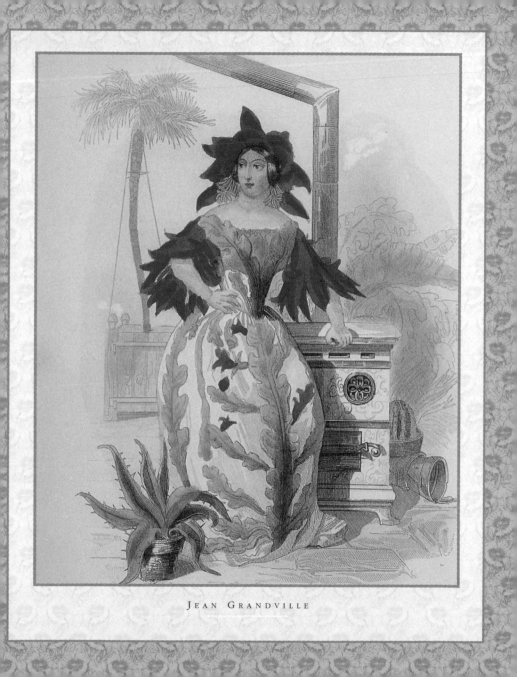

JEAN GRANDVILLE

THE LANGUAGE OF THE HEART

The romantic sensibility of the Victorian woman was fueled by the sentimentality of flowers. The artist Jean Grandville portrayed beautiful women literally *as* flowers. J. J. Rousseau's *Lettres Elementaires sur la Botanique* (1781) was translated into English and dedicated, with great literary embellishment, "To the Ladies of Great Britain no less Eminent for their Elegant and Useful Accomplishments, than admired for the beauty of their persons: This fifth edition of the following Letters is, with all Humility, inscribed by the Translator and Editor."

The passion for flowers was just as prevalent in France at the turn of the century as it was in Great Britain, especially because of artists such as Prevost, Bessa, Turpin, Poiteau, and Redouté. Flower books were very popular. The purely sentimental flower books originated in France with the 1819 publication of *Le Langage des Fleurs* by Charlotte de

F. P. Nodder illustration for J. J. Rousseau's *Lettres Elementaires sur la Botanique.*

la Tour (possibly a pen name for Mme. Louise Cortombert, although the actual author has never been firmly determined). The book, a romantic journey, devoted special symbolism to certain flowers. In effect, the flowers themselves told the story.

Assigning special meanings to particular flowers derived from the Turkish custom of the 1700s in which women were prohibited from speaking to men and so sent messages via flowers. For example, a jonquil meant "Have pity on my passion," and a rose asked "May I have all your love forever?" In Europe, in 1763, Lady Mary Wortley Montagu published her *Turkish Letters*, explaining the custom in great detail.

Charlotte de la Tour's *The Language of Flowers*, which popularized this tradition in France, developed a huge cult following in England. Here was an acceptable vocabulary allowing Victorian women to send and receive messages of

love, affection, and passion without fear of interference from parents or chaperones. Secret lovers—and there were many in that repressed society—were afforded a rare opportunity to express their innermost feelings. Even Christmas cards held secret messages that would have shocked any proper chaperone, and Valentine cards illustrated with flowers expressed the true sentiments of the lovelorn. "Honeysuckle," reads one, "thy captive I am most willingly!" The language of flowers was a novelty that was both ambiguous and in keeping with the convoluted ways of Victorian courtship.

While each flower had a particular message, the manner in which the flower was presented also carried with it a special significance. In 1875, Robert Tyas defined the finer points of flower presentation in *The Language of Flowers or Floral Emblems*. "The first rule in the Language of Flowers is, that a flower,

PANCRACE BESSA
ILLUSTRATION FOR
LE LANGAGE DES FLEURS.

presented in an upright position, expresses a thought; and to express the opposite of that thought, it suffices to let the flower hang down reversed. Thus, for example, a Rose-bud, with its thorns and leaves, says, 'I fear, but I hope.' If we present this same Rose-bud, reversed, it means 'You must neither fear nor hope.'

"But there are diverse modifications of a sentiment. It is easy to make these modifications even by means of a single flower. Take the Rose-bud, which has already served for an example. Stripped of its thorns, it says, 'There is everything to hope for.' Stripped of its leaves, it says, 'There is everything to fear.' One may also vary the expression of any flower, by altering its position. The Marigold, for instance: placed upon the head, it signifies, *sorrows of the mind*; placed above the heart, it speaks of *the pangs of love*; resting upon the breast, it expresses *ennui*. It must also be

remembered that the pronoun of the first person is indicated by inclining the flower to the left the pronoun of the second person by inclining the flower to the right. Such are the primary elements of our mysterious language."

Ever open to different interpretation, the language of flowers spawned a multitude of sequels: *Flora's Interpreter,* by Sarah Josepha Hale; *Flora's Gems,* by Louisa Anne Twamley; *The Language of Flowers,* edited by Miss Drew; *The Moral of Flowers,* by Mrs. R. Hey; *Flora's Lexicon,* by Catherine Waterman; *The Floral Offering* (1868), edited by Frances Osgood Dumont; and scores of others, including at least a dozen with the title *The Language of Flowers.*

Sentimental flower books had little scientific merit or information about plants; nonetheless they became the rage in Europe and were as popular in their day as the romance novel is today.

A FINE-ART ILLUSTRATION BY AN ANONYMOUS FEMALE ARTIST AS PUBLISHED IN *BOTANICAL SPECIMENS.*

For the purpose of making the Language of Flowers fully understood, it is necessary to lay down certain rules for the guidance of the learner; and by attention to the following instructions, it will soon become a delightful occupation, and a perfect knowledge of the art will in short time be gained.

❧ DIRECTIONS ❧

1. A flower presented with leaves on its stem expresses affirmatively the sentiment of which is the emblem;—stripped of its leaves it has a negative meaning:—if the plant be flowerless, the latter is expressed by cutting the tops of the leaves.

2. When a flower is given, the pronoun *I* is implied by inclining it to the *left*, and the word *thou* by inclining to the *right*.

3. If an answer to a question is implied by the gift of a flower, presenting it to the left hand gives an affirmative, and to the right a negative reply.

4. The position in which a flower is worn may alter its meaning—on the head it conveys one sentiment, as *Caution*; on the breast another, as *Remembrance* or *Friendship*; and over the heart a third, as *Love*.

5. If the flower be sent, the knot of the ribbon or silk with which it is tied should be on the left as you look at the front of the blossoms, to express *I* or *me*; on the right *thee* or *thou*.

—*THE LANGUAGE OF FLOWERS*

Anonymous, undated

AMERICAN WOMEN OF FLOWERS

In America, the attitude towards women was somewhat more enlightened, at least by comparison with England. The American wife was considered to be a helpmate who tended to the home, family, and garden. She was expected to perform a certain amount of work. The gentle Englishwoman was treated more as a delicate flower to be adored but not touched, and certainly not tainted by working at a profession.

Yet women on both sides of the Atlantic shared a love of flowers. American women hoarded books about botany and the study of nature that were published in England, and they eagerly awaited the arrival of the new sentimental flower books from France.

Soon American publishers were printing their own books on the subject. One of the first sentimental flower books to appear in America in the mid-nineteenth century was a small volume entitled *Flora and Thalia, or Gems of*

> I HAD RATHER WEAR HER GRACE
> THAN AN EARL'S DISTINGUISHED FACE;
> I HAD RATHER DWELL LIKE HER
> THAN BE DUKE OF EXETER
> ROYALTY ENOUGH FOR ME
> TO SUBDUE THE BUMBLE-BEE!
>
> —EMILY DICKINSON, "MY ROSE"

Flowers & Poetry By a Lady. The book was written anonymously, and the plates appear to be borrowed from an English book.

Flora's Lexicon: An Interpretation of the Language and Sentiment of Flowers was published in New York in about 1865 by Catherine Waterman. *The Poetical Language of Flowers* by Thomas Miller was published in 1847, as were *The Poetry of Flowers* and *The Flowers of Poetry*, both with unsigned hand-colored plates.

Sarah Hale's *Flora's Interpreter, or the American Book of Flowers and Sentiments* (1832-34) was actually a book of poetry about flowers. Lucy Hooper's book, *The Lady's Book of Flowers and Poetry* (1824), was similar but also told readers how to cultivate plants, and included beautiful floral illustrations.

In 1867 in New York, Mrs. C. W. Badger published *Floral Belles from the Greenhouse and Garden* with some fine hand-colored lithographed plates; two

BURR CLOVER BY EMMA HOMAN THAYER.

years later, her *Wild Flowers Drawn and Colored from Nature* appeared. Both of these works combine poetry with flowers and are prime examples of the Victorian ideal of books suitable for ladies. They are sentimental in content and teach goodness and love of nature.

In the late nineteenth century, government-sponsored publications such as the annual *Yearbook for the U.S. Department of Agriculture* gave American women an important entrance into the field of botanical art. Many women were employed. Agnes Chase and Cordelia Stanwood, for example, executed excellent botanical

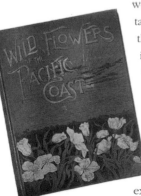

studies of America's flora and fauna. It was an age of discovery, and America wanted to show Europe, specifically England, that it could also excel in botanical art and that the natural beauty of America's flowers and plants was equal to that of Great Britain.

American women educated themselves in the new science of botany and Linnaeus' system of plant classification. The American Emma Homan Thayer, for example, was an accomplished illustrator of plants and flowers. She traveled throughout the west, collecting and illustrating specimens that she found there. Writing in a diary style, she expertly illustrated both of her books, *Wild Flowers of Colorado* and *Wild Flowers of the Pacific Coast*, published in 1885 and 1887 respectively. By the turn of the twentieth century, female illustrators were hard at work in the United States in the fields of botany, ornithology, entomology, conchology, and biology.

❧ WOMEN OF FLOWERS ❧

I WILL BE THE GLADDEST THING UNDER THE SUN,
I WILL TOUCH A HUNDRED FLOWERS AND NOT PICK ONE.
—EDNA ST. VINCENT MILLAY

So despite resistance from male critics, social restrictions, and limited opportunities, women botanists and floral artists of the Victorian era persevered, leaving a lasting legacy of beautiful flowers. Hidden away and ignored for decades, botanical art has once again become very popular. Interest in botanical drawings was triggered by decorators and art collectors during the 1970s and has only increased in the past two decades. These overlooked female artists are finally receiving the attention and acclaim they so richly deserve. Recently, an 1841 volume of Jane Loudon's *The Ladies' Flower Garden of Ornamental Perennials* sold for $4,000. A single floral plate of Maria Sibylla Merian's sells for $3,800, and volumes one to five of Maund's *The Botanist*, a periodical featuring the works of many female artists, command more than $3,000 at auction. But perhaps Mrs. Bury is the best example of the true

ABOVE: *CLIANTHUS PUNICEUS* BY PRISCILLA SUSAN BURY. OPPOSITE: THISTLE BY MARGARETA B. DIETZSCH. (COURTESY OF THE FITZWILLIAM MUSEUM, UNIVERSITY OF CAMBRIDGE)

value of these artists. In 1831 she published *A Selection of Hexandrian Plates* with seventy-nine subscribers. In 1986, Sotheby's sold the folio by Mrs. Bury for £48,400.

Scholarly works are also beginning to acknowledge the contribution of women botanical artists. In his 1990 book, *Botanical Masters*, author William T. Stearn examines contemporary botanical artists, and all but three of the fifty-five plates are executed by women. The famous Broughton collection of botanical art in the Fitzwilliam Museum includes more than 300 drawings, paintings, and prints by women (out of a total of 1,200). These include Margareta B. Dietzsch, Nathalie d'Esmenard, and Elizabeth Burgoyne, active in the eighteenth and nineteenth centuries. Today in the Kew collection, works by women artists outnumber those of men almost two to one. Finally, Victorian women of flowers are blossoming in the light of their achievements.

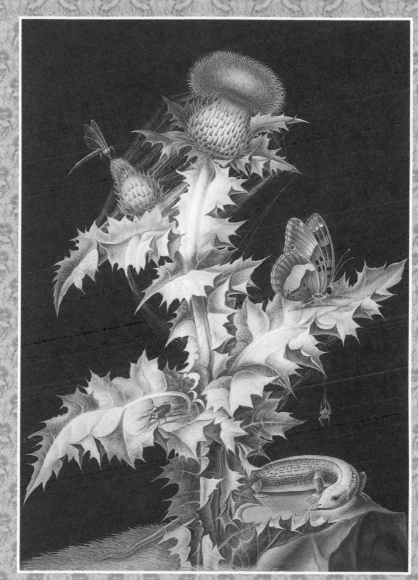

MARGARETA BARBARA DIETZSCH

*L*OOK AT THE CHAIR ON WHICH YOUR FRIEND IS

SITTING, AT THE CARPET BENEATH YOUR FEET, AT THE

PAPER ON THE WALLS, AT THE CURTAINS WHICH SHUT OUT

THE WINTRY LANDSCAPE, AT THE TABLE NEAR YOU, AT THE

CLOCK, THE CANDLESTICKS, NAY, THE VERY FIRE-IRONS—OR

IT MAY BE THE IRON MOULDINGS UPON YOUR STOVE—AT THE

PICTURE-FRAMES, THE BOOK-CASE, THE TABLE-COVERS, THE

WORK-BOX, THE INKSTAND, IN SHORT, ALL OF THE

TRIFLING KNICK-KNACKS IN THE ROOM, AND ON

ALL THESE YOU MAY SEE, IN BOLDER OR

FAINTER LINES, A THOUSAND PROOFS OF

THE DEBT WE OWE TO THE VEGETABLE

WORLD, NOT ONLY FOR SO MANY OF THE

FABRICS THEMSELVES, BUT ALSO FOR

THE BEAUTIFUL FORMS, AND COLORS,

AND ORNAMENTS WE SEEK TO IMITATE.

BRANCHES AND STEMS, LEAVES AND

TENDRILS, FLOWERS AND
FRUITS, NUTS AND
BERRIES, ARE EVERY-
WHERE THE MODELS. . . .
THE MOST DURABLE AND
COSTLY MATERIALS THE EARTH
HOLDS IN HER BOSOM, STONE AND
MARBLE, GOLD, SILVER, AND GEMS,
HAVE BEEN MADE TO ASSUME, IN A THOUSAND
IMPOSING OR GRACEFUL FORMS, THE LINES
OF THE LIVING VEGETATION. HOW MANY OF
THE PROUDEST WORKS OF ART WOULD
BE WANTING, IF THERE HAD BEEN NO GRACE
AND DIGNITY IN TREES, NO BEAUTY IN
LEAVES AND FLOWERS!

—SUSAN FENIMORE COOPER,

RURAL HOURS BY A LADY, 1854

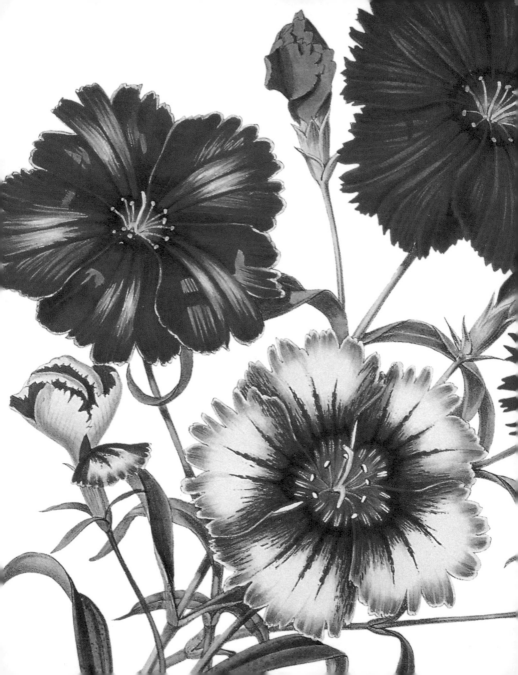

WOMEN of FLOWERS

OH! THOU MAGIC WORLD OF FLOWERS . . .

THE SPELL OF LOVE, THE VOICE OF POWER,
MAY THRILL US FROM A SINGLE FLOWER.

—LUCY HOOPER
POETRY OF FLOWERS

MRS. CLARISSA W. MUNGER BADGER
(1806–1889)

*B*oth Clarissa Munger and her sister, Caroline, were artists. Caroline went on to become proficient at painting miniature portraits on ivory that were quite popular in their day. Clarissa concentrated her talents on drawing plants and flowers.

In 1828 Clarissa married the Reverend Milton Badger. During their marriage, they lived together in Andover, Massachusetts; New York City; and Madison, Connecticut. In 1859 Mrs. Badger published *Wild Flowers of America.*

> BEAUTIFUL FLOWERS . . .
> WERE YOUR TINTS AND ODORS GIVEN
> TO GRANT THE SPIRIT, IN THE SHADE
> OF THIS DULL WORLD, SOME GLIMPSE OF HEAVEN?
>
> —W. MARTIN, FROM THE PREFACE TO
> *FLORAL BELLES* BY MRS. C. W. BADGER

Her most important book, however, was *Floral Belles,* which is considered a milestone in publishing and an American classic in botany. Published by Charles Scribner's & Co., the book is a large, folio-sized volume with exquisite hand-colored drawings of flowers. *Floral Belles* instituted a host of imitators. Though little is known about her life other than the landmark dates of her birth, marriage, and death, Mrs. Clarissa W. Munger Badger's fine drawings and talented hand have survived to keep her name alive.

OPPOSITE: THE NIGHT-BLOOMING *CEREUS* WAS A SPECTACLE IN THE NINETEENTH CENTURY, DRAWING LATE-NIGHT ADMIRERS TO WATCH ITS TWENTY-FOUR-HOUR BLOSSOM.

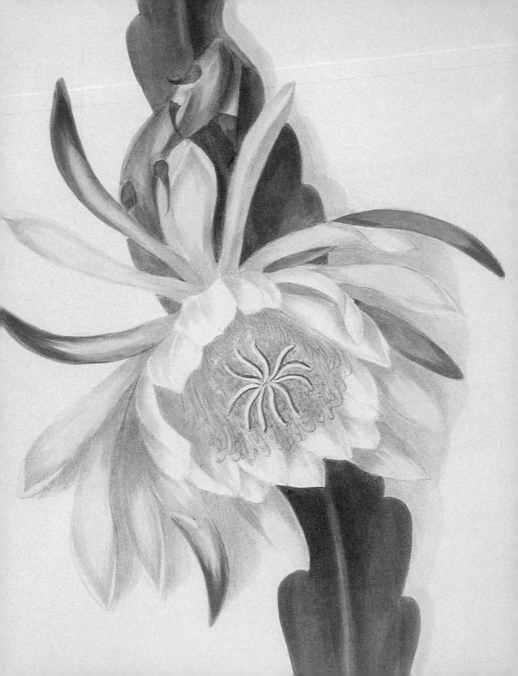

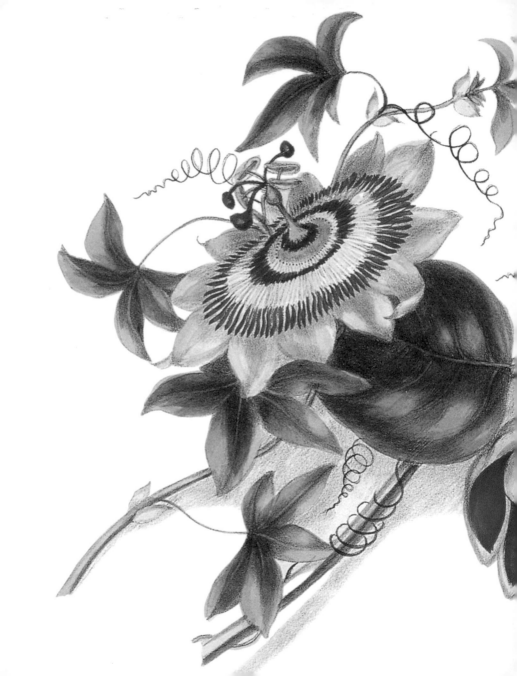

ABOVE: CAMELLIAS WERE
AMONG THE MOST POPULAR
FLOWERS OF THE VICTORIAN
ERA. THIS EXCELLENT RENDI-
TION BY MRS. BADGER
APPEARED IN HER BOOK
FLORAL BELLES, WHICH WAS
PUBLISHED BY CHARLES
SCRIBNER'S, NEW YORK, IN
1867. TODAY *FLORAL BELLES*
IS CONSIDERED AN AMERICAN
BOTANICAL CLASSIC.

LEFT: TWO SPECIES OF
PASSIONFLOWER BY MRS.
BADGER. THESE LARGE
OPEN-FACED FLOWERS WERE
CONSIDERED QUITE EXOTIC
IN VICTORIAN TIMES.

OVERLEAF: MRS. BADGER'S
HANDSOME BOUQUET OF
ANEMONES (LEFT) AND A
COLORFUL ARRAY OF TULIPS,
WHICH WERE—AND
REMAIN—A FAVORITE FLOWER
AMONG ARTISTS.

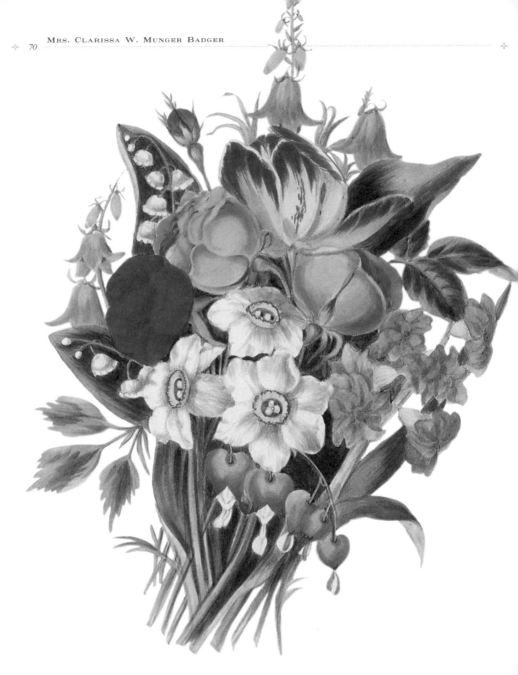

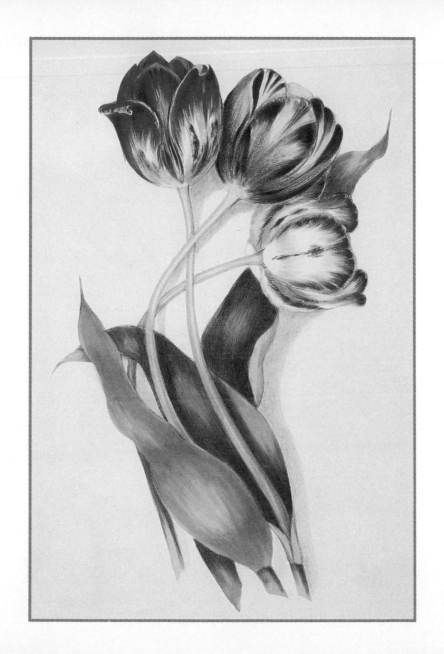

Male-Piony.

Eliz. Blackwell delin. sculp. et Pinx.

1. Flower.
2. Seed Vessel.
3. Seed Vessel open.
4. Seed.

Paeonia mas.

ELIZABETH BLACKWELL
(1700–1758)

*B*orn in Aberdeen, Scotland, Elizabeth Blackwell married her second cousin, Alexander Blackwell, when she was twenty-eight years old. The couple moved to London, where Alexander opened a print shop, albeit illegally. The law required a specific amount of apprenticeship training, and Alexander had worked only briefly with a printer. For this crime, he was sent to prison for two years.

With her husband gone, Elizabeth worried about going into debt. Through friends in the medical profession, she discovered there was a genuine need for a definitive herbal guide, and she decided to produce a book that would serve as such a reference for doctors.

Blackwell was encouraged in her work by Sir Hans Sloane, curator of the Botanical Garden at Chelsea. She began working in a house opposite the Chelsea Physic Garden. There she would draw an array of fresh plants. She also engraved her own images on copper plates and then hand-colored the prints herself. This was a tremendous accomplishment because at the time, most botanical prints were rendered by three separate artisans—a sketcher, an engraver, and a painter.

From prison, Blackwell's husband contributed to the book, furnishing the text in several languages. The first volume of *A Curious Herbal,* which included 500 plates, was published in 1738. Elizabeth Blackwell's work, although quite good, was never considered exceptional. Her drawings were rendered with a somewhat heavy hand and were not always botanically correct. Nevertheless, *A Curious Herbal* was an excellent record for its time and its success lay in fulfilling a need for identifying and portraying hundreds of medicinal plants. It

OPPOSITE: THIS EXQUISITE PEONY IS ONE OF FIVE HUNDRED ILLUSTRATIONS DRAWN BY ELIZABETH BLACKWELL TO EARN ENOUGH MONEY TO FREE HER HUSBAND FROM DEBTOR'S PRISON.

was, in fact, the first complete herbal reference of that period.

And Blackwell was an enterprising young woman. In her book, she acknowledged the contributions of several prominent men, and she promoted her book by word of mouth. She placed advertisements in various journals. She made special sales arrangements with booksellers. As a consequence, the book was a financial success.

Blackwell's husband was vindicated and for a brief time became the Director of Improvements in the service of James Brydges, Duke of Chandos. But something happened during his tenure with Brydges and he was forced to resign under a cloud of suspicion. He went to Sweden in 1742 and got involved in a confusing morass of political intrigue. Arrested and charged with conspiracy to alter Swedish succession, Alexander was convicted of high treason. He was sentenced to be executed.

Fearful for her own safety, Elizabeth Blackwell had not gone to Sweden with her husband. Upon hearing of his conviction, however, she wanted to go to him. Wisely, she was persuaded to stay home. Although she never saw her husband again, Blackwell's devotion to him was unswerving.

Alexander Blackwell was executed in 1747.

After his death, Elizabeth stopped working. Little is known about the brief and final chapter of her life. She survived her husband by only eleven years and died alone in 1758.

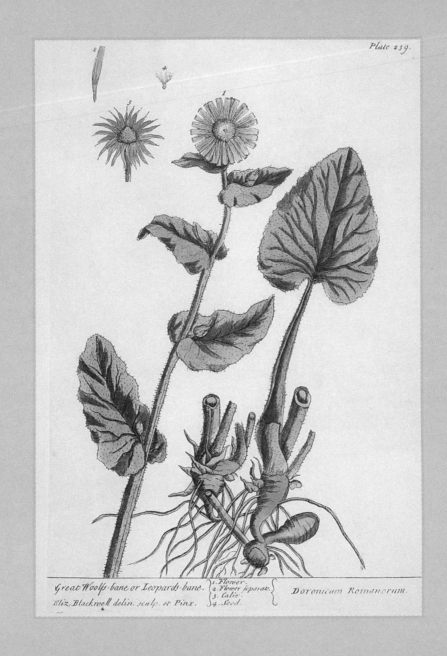

Plate 239.

Great Woolfs-bane or Leopards-bane. ⎰ 1. Flower.
⎱ 2. Flower separate. Doronicum Romanorum.
⎰ 3. Calix.
Eliz. Blackwell delin. sculp. et Pinx. ⎱ 4. Seed.

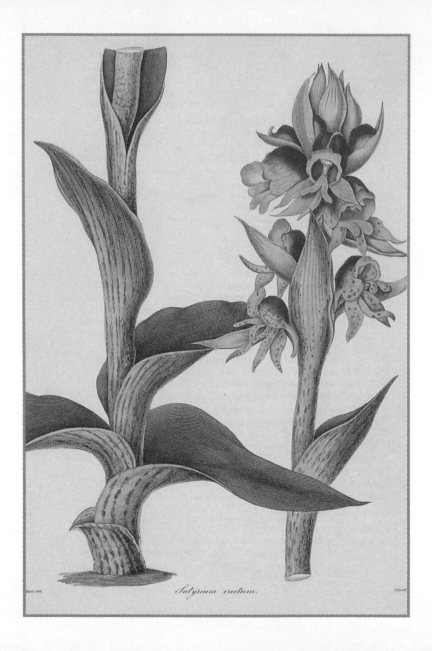

Satyrium erectum.

PRISCILLA SUSAN BURY
(C. MID-1820S—LATE 1860S)

*P*riscilla Susan Faulkner was born into a family of wealth and privilege. Her father, Edward Dean Faulkner was a rich Liverpool merchant, a justice of the peace and high sheriff of Lancashire; her mother was the only daughter of John Tarleton, an M.P. for Wavertree and a wealthy landowner himself. The infant was named for her maternal grandmother, Susan Precilla Bertie.

She grew up on an estate called Fairfield, two miles outside Liverpool, where rare and beautiful plants were grown in the family's hothouses. At a young age, Priscilla took an interest in painting these exotic flowers. She concentrated on the lilies and related families of flowers. By 1829, she had enough illustrations (or "portraits," as she called them) to consider publication.

Priscilla Bury consulted with zoologist William Swainson, and he encouraged her to publish her work. She was also aided by William Roscoe, a botanist and noted patron of the arts and sciences in Liverpool.

From 1831 to 1834, Bury produced fifty-one plates of amaryllis and lilies in a work entitled *A Selection of Hexandrian Plants*. According to an article written about Priscilla Bury by Nora McMillan, the artist probably modeled her book on Roscoe's *Monandrian Plants*. In any case, Bury hired the renowned craftsman Robert Havell as engraver and colorist for her book. Havell, known for his work on Audubon's prints, received a great deal of the credit for the superb reproductions in *Hexandrian Plants*, which was unfortunate because the credit he received detracted from the superb quality of Bury's work.

ABOVE: MRS. BURY'S DRAWING
WAS LABELED A DELPHINIUM
WHEN IT APPEARED IN *THE
BOTANIST*. IT IS ACTUALLY AN
AQUILEGIA. (MISLABELING WAS
NOT UNCOMMON IN THE NINE-
TEENTH CENTURY.)
OPPOSITE: IN BENJAMIN
MAUND'S PERIODICAL *THE
BOTANIST*, MRS. BURY
PUBLISHED THIS ILLUSTRATION
OF AN *ECHEVERIA*, A SUCCULENT
PLANT.

Though she continued to work in botanical illustration, contributing work to Benjamin Maund's *Botanic Garden* and *The Botanist* between the years 1837 and 1846, Bury was greatly stung by criticisms of *Hexandrian Plants*. One reviewer wrote: "Probably her marriage in 1830 to a wealthy engineer meant she could afford the best, and copperplate was done instead of lithography." Perhaps this was one of the reasons why she abandoned flower painting and turned to microscopy. In 1860-1861, she produced *Figures of remarkable forms of Polycyctins, or allied organisms in the Barbados chalk deposits . . . Drawn by Mrs. Bury, as seen in her microscope on slides prepared by Chr. Johnson, Esq., of Lancaster.*

Also in 1860, she published a memoir about her husband entitled *Recollections of Edward Bury, by His Widow (P. S. Bury)*, which recounted Edward's career as an engineer.

After the mid 1860s, Priscilla Bury probably returned to Fairfield to live on her family estate. The exact date of her death is unknown.

Today the original drawings for *Figures of remarkable forms of Polycyctins* are owned by the Liverpool City Libraries, a present donated to the city in 1942 by Miss F. Bury, Priscilla Bury's granddaughter.

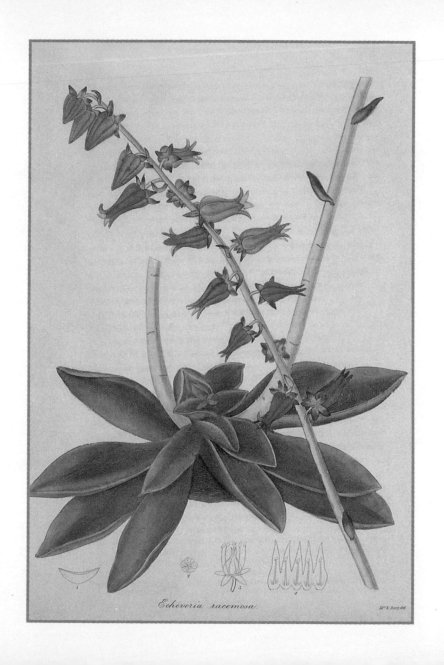

Echeveria racemosa.

AGNES CATLOW
(c. 1807—1889)

BELOW AND OPPOSITE:
A VARIETY OF BOTANICAL
DRAWINGS BY AGNES CATLOW.

*T*rained in the fields of nature, zoology, and entomology, Agnes Catlow gathered a great following with *Popular Conchology*, published in 1842. Reviewing her *Drops of Water* in 1851, the *London Standard* raved that "The plates are scarcely inferior to those of the well known Ehrenberg . . ."

Catlow was also the author of several botanical books including *Popular Field Botany*, published in 1855, and *Popular Greenhouse Botany*, which appeared two years later. Along with her sister, Maria E. Catlow, she published *The Children's Garden and What They Made of It.*

In the preface to *Popular Garden Botany*, she expressed a popular Victorian sentiment concerning the merits of the study of botany for children. "This book was originally compiled for the use of some young friends of the author and used by them in manuscript with sufficient success to induce its publication, in the hope that it might contribute to some other young botanists and lay the foundation for much interesting amusement. It is a pursuit congenial to the young and active; and above all to those who delight in the examination of

> BOTANY IS ONE OF THE MOST PLEASING BRANCHES OF NATURAL HISTORY, AND IN SOME DEGREE A NECESSARY ATTAINMENT FOR EVERY WELL CULTIVATED MIND, AS WELL AS MOST BENEFICIAL IN MANY WAYS TO THE YOUNG STUDENT. . . . BOTANY IS EASILY PURSUED BY THOSE LIVING IN THE COUNTRY, AND IS NOT AN EXPENSIVE PLEASURE, WHILST THE THOUGHTS CONNECTED WITH IT ARE PURE AND REFRESHING, FORMING A DELIGHTFUL RELAXATION FROM MORE SERIOUS DUTIES.
>
> —AGNES CATLOW,
> *POPULAR FIELD BOTANY*, 1848

Plate 11.

41.

42.

Fumaria officinalis, *Linn.*

Orobus tuberosus, *Linn.*

43.

44.

Hieracium Pilosella, *Linn.*

Hippuris vulgaris, *Linn.*

Reeve, lith. et imp.

works of nature; a study to which we are urged . . . by our own feeling of propriety, as showing a due reverence for the gifts of God."

Yet for all of her popularity, little is known about this talented woman. London's *Notes and Queries* remarked that "Miss Catlow's abilities as a naturalist and her tact in popularizing any subject she undertakes are too well known to need iteration on this occasion." Unfortunately, those more intimate details of her personal life have not survived, though we do have her work and her ideas to inform us of her myriad talents and abilities.

THIS PAGE AND OVERLEAF: AGNES CATLOW'S PLATES IN *POPULAR FIELD BOTANY* WERE BOTANICALLY CORRECT AND FINELY EXECUTED. LEFT: *SOLANUM DULCAMARA*. RIGHT: *EPILOBIUM HIRSTUTUM*.

Plate 18.

69.

70.

Betonica officinalis, *Smith*.

Stachys sylvatica, *Linn*.

71.

72.

Scutellaria galericulata, *Linn*.

Spargánium ramosum, *Huds*.

Reeve lith. et imp.

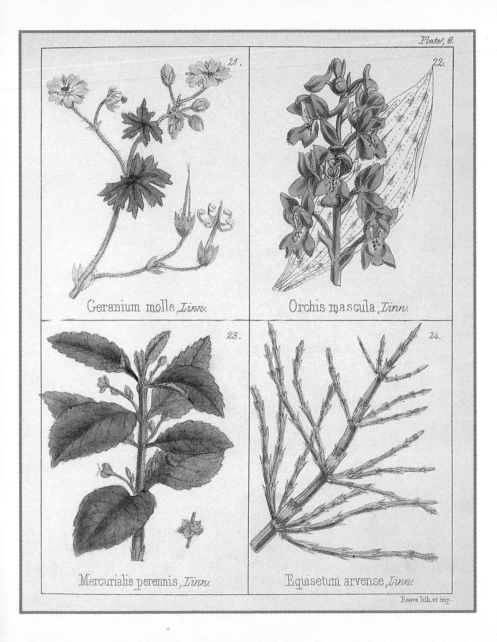

21.

Geranium molle, *Linn.*

22.

Orchis mascula, *Linn.*

23.

Mercurialis perennis, *Linn.*

24.

Equisetum arvense, *Linn.*

Reeve lith. et imp.

SUSAN FENIMORE COOPER
(1813–1894)

*S*usan Fenimore Cooper was the daughter of James Fenimore Cooper, the renowned author of *The Last of the Mohicans*. Most of her life was devoted to her father. She traveled with him on his numerous journeys and functioned as his secretary, copying and arranging his notes. Although she never married or raised a family of her own, she eventually became an accomplished naturalist in her own right.

While working for her father, Susan Cooper kept a meticulous daily diary, which she later transformed into her first published book. Entitled *Rural Hours by a Lady*, the book was a rambling yet highly observant look at daily life in upstate New York in the 1850s, with long discussions about nature and accomplished drawings of the flowers, plants, and birds indigenous to that area. Unlike many sentimental flower books that were so popular in England at the time, *Rural Hours* was almost scientific in its descriptive details of the environment. At the same time, it afforded a fascinating look at the everyday life of the country woman in mid-nineteenth-century America. The glory of the American land and the spirit of the American woman blossomed in Cooper's writing. In the dozen full-color plates, Cooper extolled nature and she had a basic knowledge of botany. *Rural Hours* went through six editions; the last one

> FRIDAY, 13TH—DELIGHTFUL DAY. LONG WALK IN THE WOODS. FOUND A FEW ASTERS AND GOLDEN-RODS, SILVER-RODS, AND EVERLASTINGS, SCATTERED ABOUT. THE FLOWERS ARE BECOMING RARE, AND CHARY OF THEIR PRESENCE; STILL, SO LONG AS THE GREEN GRASS GROWS, THEY LIE SCATTERED ABOUT, ONE HERE, ANOTHER THERE, IT MAY BE IN THE SHADY WOODS, OR IT MAY BE IN THE FLOWER-BORDER; REMINDING ONE OF THOSE PRECIOUS THINGS WHICH SWEETEN THE FIELD OF LIFE—KINDLY FEELINGS, HOLY THOUGHTS, AND JUST DEEDS—WHICH MAY STILL BE GLEANED BY THOSE WHO EARNESTLY SEEK THEM, EVEN IN THE LATEST DAYS OF GREAT PILGRIMAGE.
>
> —SUSAN FENIMORE COOPER, *RURAL HOURS BY A LADY*

OPPOSITE: SUSAN FENIMORE COOPER, DAUGHTER OF JAMES FENIMORE COOPER, WROTE *RURAL HOURS* IN THE MID-NINETEENTH CENTURY, A PIONEERING EFFORT FOR WOMEN NATURALISTS. THIS LOVELY BIRD WAS ONE OF ABOUT A DOZEN COLOR ILLUSTRATIONS IN THE BOOK.

BLUE JAY.

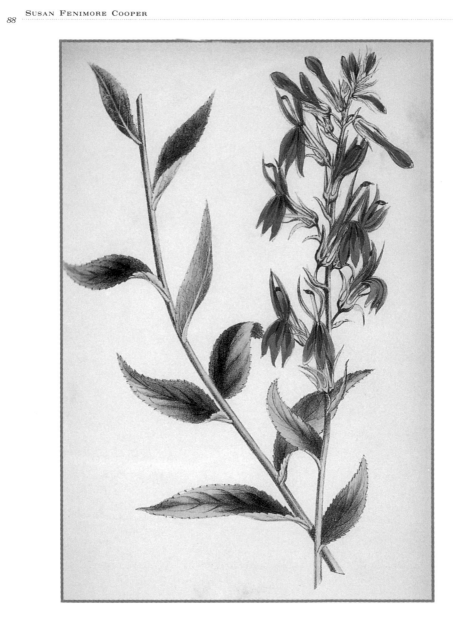

was published in 1887.

Less successful were the two books Susan Cooper published in 1854, *Rhyme and Reason of Country Life* and *Rural Rambles*. In 1861 she wrote *Pages and Pictures from the Writings of James Fenimore Cooper*, as well as the preface to her father's *Household Editions*, published from 1876 to 1884.

Much of her energy during this period, and until the time of her death, was devoted to charitable pursuits. She founded the Orphan House of the Holy Savior in Cooperstown, New York, in 1873. Under her tutelage, the institution grew to provide a home for more than one hundred girls and boys. At the same time, she continued to write, mostly about the spiritual aspects of her life, with occasional musings on nature

Today, of course, her work is totally overshadowed by that of her famous father and she is but a literary footnote to her time. Still, her books remain a lasting legacy, a rare glimpse into a life lived in a previous century when women were first allowed entrance into the world of science and botany. Susan Cooper was certainly a pioneer in her time.

OPPOSITE: THE CARDINAL FLOWER PUBLISHED IN SUSAN FENIMORE COOPER'S BOOK, *RURAL HOURS*, WAS ONLY ONE OF MANY THAT SHE DESCRIBED IN HER WRITINGS, WHICH WERE MAINLY CONCERNED WITH THE NATURAL BEAUTY OF UPSTATE NEW YORK.

THOSE WHO LIVE IN OUR LARGE TOWNS, WHERE THEY BUY EVEN THEIR BREAD AND BUTTER, THEIR MILK AND RADISHES, HAVE NO IDEA OF THE LARGE AMOUNT OF DOMESTIC GOODS, IN WOOL AND COTTON, MADE BY THE WOMEN OF THE RURAL POPULATION OF THE INTERIOR, EVEN IN THESE DAYS OF HUGE FACTORIES. WITHOUT TOUCHING UPON THE SUBJECT OF POLITICAL ECONOMY, ALTHOUGH ITS MORAL ASPECT MUST EVER BE A HIGHLY IMPORTANT ONE, IT IS CERTAINLY PLEASANT TO SEE THE WOMEN BUSY IN THIS WAY, BENEATH THE FAMILY ROOF, AND ONE IS MUCH DISPOSED TO BELIEVE THAT THE HOME SYSTEM IS HEALTHIEST AND SAFER FOR THE INDIVIDUAL, IN EVERY WAY. HOME, WE MAY REST ASSURED, WILL ALWAYS BE, AS A RULE, THE BEST PLACE FOR A WOMAN; HER LABORS, PLEASURES, AND INTERESTS, SHOULD ALL CENTRE THERE, WHATEVER BE HER SPHERE OF LIFE.

—SUSAN FENIMORE COOPER, *RURAL HOURS BY A LADY*

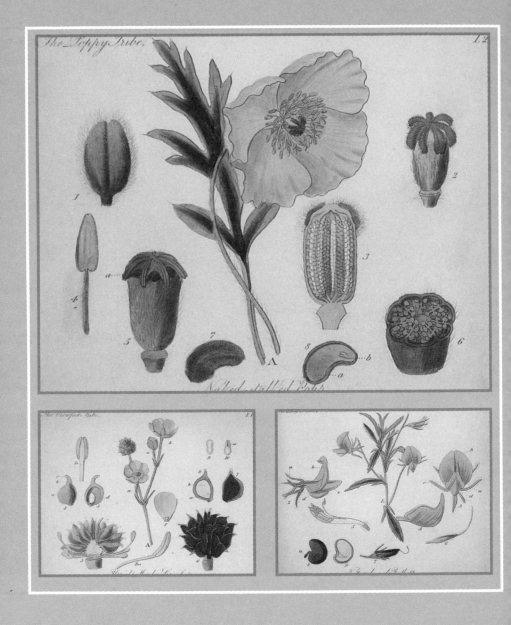

Naked-stalked Poppy.

The Crowfoot Tribe.

II.

The Pea or Butterfly Tribe.

MISS S. A. DRAKE
(FLOURISHED 1830–1840s)

*M*iss S. A. Drake is one of the most elusive of all Victorian botanical artists. During her lifetime, she produced an enormous and impressive body of work, but almost nothing is known of her except that she lived in a part of London called Turnham Green. Never married, she apparently led a rather solitary life, perhaps due to the mammoth amount of work she executed for so many clients.

Miss S. A. Drake contributed magnificent plates of orchids to Bateman's famous volume, *Orchidaceae of Mexico and Guatemala*, probably the single most famous orchid book every published. Surely Miss Drake must have had contact with orchids sometime in her life. It would seem almost impossible for anyone to portray orchids in such a fine and detailed manner without formal training and first-hand experience.

Miss Drake also produced plates for John Lindley's fine volume, *Sertum Orchidaceae*. Lindley was professor of Botany at London University from 1829 to 1860 and a professor of botany to the Society of Apothecaries, and

OPPOSITE: A POPPY (ABOVE) AND A CROWFOOT (BELOW) AS EXECUTED BY MISS DRAKE. BELOW: A STRAWBERRY, DRAWN IN GREAT DETAIL BY MISS DRAKE FOR *LADIES BOTANY*.

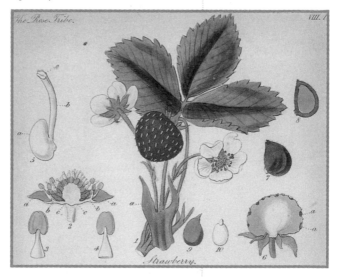

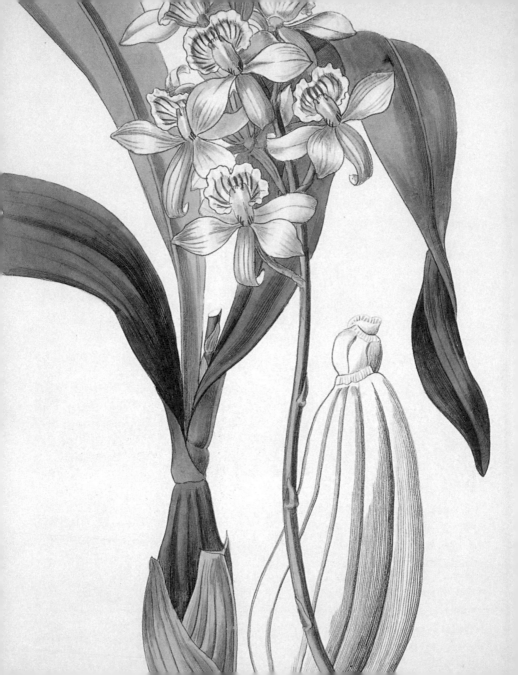

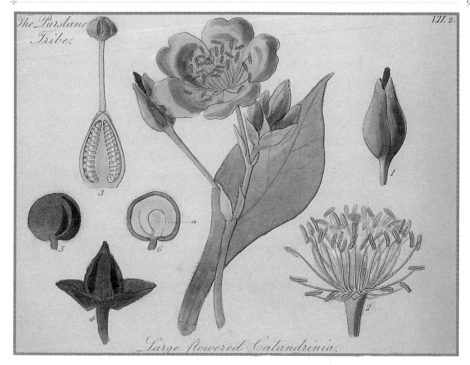

he was active in the Royal Horticultural Society as well. The Lindleys also lived in Turnham Green, and Miss Drake may have been related to them. There is a reference to Miss Drake in an 1839 letter written by Professor Asa Gray, a man of science and botany who was devoted to the flora of North America. He claimed that Miss Drake was "always at Lindley's home and is probably a friend of the family or a relative." In any case, John Lindley must have been quite fond of Miss Drake. He named a plant genus after her: Drakaea.

She worked for Dr. Hamilton, and contributed three hundred beautifully hand-colored illustrations to his *Plantae Asi-*

OPPOSITE: A NICELY DETAILED ORCHID *(EPIDENDRUM)* BY MISS DRAKE.

ABOVE: A PINK *CALANDRINIA* WITH DISSECTED PARTS, DRAWN BY MISS DRAKE FOR *LADIES BOTANY.*

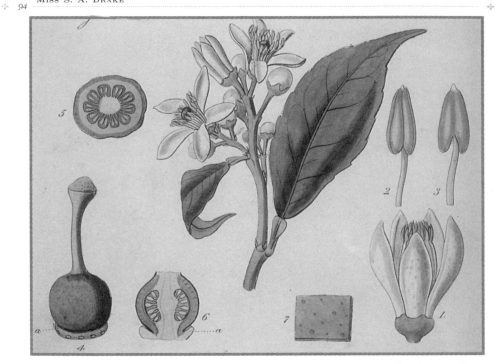

ABOVE: FLORAL PARTS FOR
LINDLEY'S LADIES BOTANY,
DRAWN BY MISS S. A. DRAKE.
OPPOSITE: MISS DRAKE POR-
TRAYS A CHORIZEMA IN THIS
FINE DRAWING EXECUTED FOR
THE TRANSACTIONS OF THE
ROYAL HORTICULTURAL SOCIETY.

aticiae Rariores, published from 1830-1832. The plates in this book were lithographed by Gauci after Miss Drake's paintings.

Perhaps the most esteemed and impressive part of her career, though, were the eleven hundred magnificent botanical plates she executed for Sydenham Edward's *Botanical Register.* When Miss Drake stopped contributing to the *Register* in 1847, the magazine almost went out of business.

Strangely enough, nothing is known of Miss S. A. Drake after 1847.

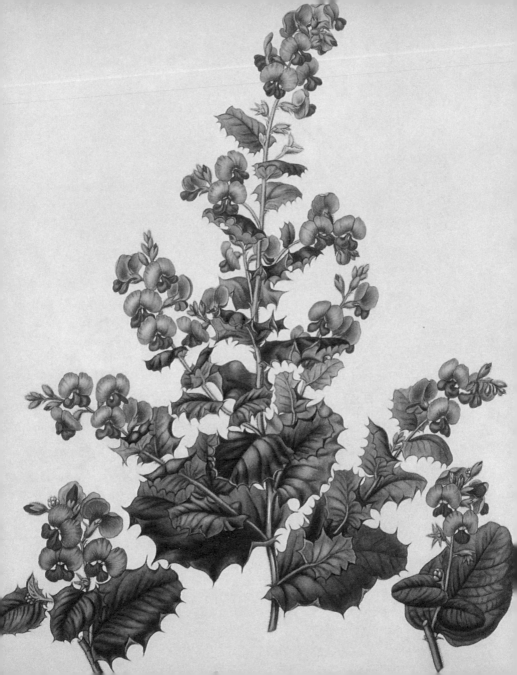

LADY HARRIET ANNE HOOKER THISELTON DYER
(1854–1945)

ABOVE: LADY THISELTON DYER
COMBINED A KNOWLEDGE OF
BOTANY WITH A REFINED SENSE
OF COMPOSITION.
OPPOSITE: LADY DYER'S
BEAUTIFUL IRIS AND AN
EXCEPTIONALLY FINE *PROTEA*
(BELOW) ARE BOTH FROM
CURTIS'S BOTANICAL MAGAZINE.

arriet Anne Hooker was the eldest daughter of Joseph Dalton Hooker and the granddaughter of Sir William Jackson Hooker, who had been director of Kew Gardens during the reign of Queen Victoria. Hooker had been responsible for expanding Kew Gardens from eleven to more than six hundred acres, opening it up for the general public to enjoy. From an early age, Harriet Anne was known for her green thumb. Plants that expired under the care of hired gardeners seemed to thrive when Harriet tended to them. She was especially fond of fuchsias.

Encouraged by her parents, Harriet Anne tended her garden, learned botany, and developed her natural talent for drawing. A friend of the family, Walter Fitch, also supported her drawing talents. Fitch was an artist for *Curtis's Botanical Magazine,* and when he resigned after years of service, Sir Joseph Dalton Hooker urged his daughter to assume the illustrative duties at the magazine. Between 1879 and 1880, Harriet Anne rendered almost ninety illustrations for publication and was partly responsible for the preservation of the magazine.

She married a man who shared her love of plants and flowers. He was also quite famous in his day. Sir William Turner Thiselton Dyer was a professor of natural history at the Royal Agricultural College and a professor of botany at both the Royal College of Science in Dublin and the Royal Horticultural Society. From 1885 to 1905, Sir William served as director of the gardens at

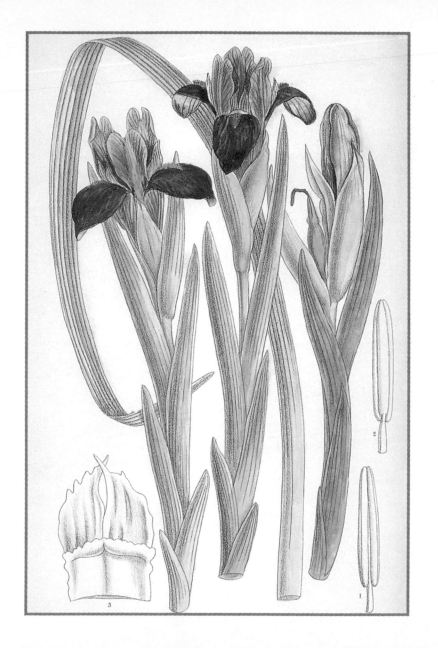

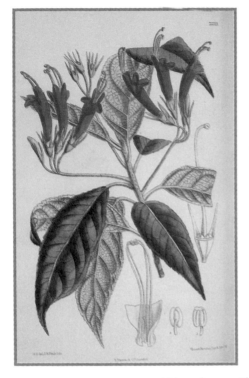

ABOVE: A *COLUMNEA* WITH ITS
TUBULAR FLOWERS.
OPPOSITE: BROMELIADS WERE A
NOVELTY IN THE MID-NINE-
TEENTH CENTURY. BOTH OF
THESE PLATES WERE DONE BY
FITCH FROM DRAWINGS
ATTRIBUTED TO LADY DYER.
THEY APPEARED IN *CURTIS'S
BOTANICAL MAGAZINE.*
OVERLEAF: AN EXOTIC AROID
(LEFT) BY LADY DYER FROM
CURTIS'S BOTANICAL MAGAZINE,
AND AN ORCHID, A *CATASETUM*
(RIGHT).

Kew, where his job was to turn the Queen's private garden into a world-class arboretum. With the help of his gracious and talented wife, Sir William succeeded admirably in this task. Lady Dyer was an avid letter writer, and she saw to it that Kew was a warm and welcoming place for visitors.

In 1905, Sir William retired and moved with Harriet to the Cotswolds. When he died there in 1928, Lady Dyer went to live in Devonshire. She was seventy-four years old, but despite her age, she managed to create a remarkable garden for herself. She was so gifted that practically everything she planted grew vigorously, especially wild orchids and roses. The February 16, 1946, issue of *Nature Magazine* called her a "très grande dame." She worked in her garden until the day she died, at the age of ninety-one.

In her distinctive drawings, Lady Dyer was able to combine her vast knowledge of horticulture, a flair for botany, and a refined sense of composition. She had a delicate hand and knew how to achieve colors that were true to the flowers she portrayed. Though very little has been written about her, she was a genuinely talented botanical artist.

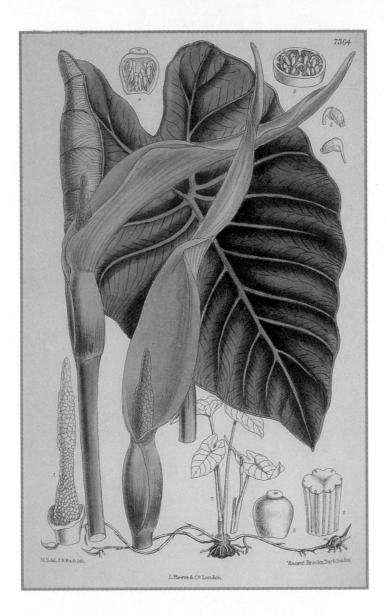

M.S.del. J.N.Fitch lith.

Vincent Brooks,Day&Son Imp.

L. Reeve & C? London.

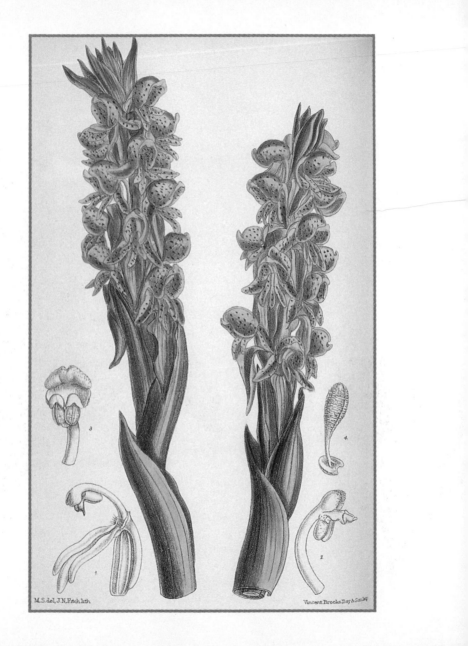

ELSIE KATHERINE DYKES
(D. 1933)

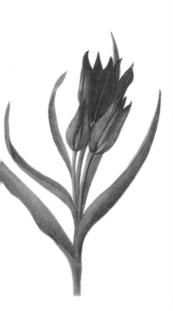

"he news of the sudden and tragic death of Mrs. W. R. Dykes on Thursday, May 25, came as a terrible shock to those who knew her, and especially to those who were at the Chelsea Show, and had seen her in the morning of that day," declared *The Gardener's Chronicle* of June 3rd, 1933. "She was returning to her home, Bobbingcourt, when the train in which she journeyed from Waterloo was involved in an accident that resulted in her death. She was one of five who lost their lives, and two of the others besides Mrs. Dykes had visited the Chelsea Show.

> "ALAS! THE LADY OF THE IRISES HAD PASSED FROM HER GARDEN . . ."
> —*THE GARDENER'S CHRONICLE,*
> JUNE 3RD, 1933

"The widow of the late Mr. William R. Dykes, who was for several years Secretary of the Royal Horticultural Society—and who lost his life in equally tragic circumstances, following injuries received in a motor accident—Mrs. Dykes was as interested in the cultivation and the nomenclature of Tulips and Irises as her husband. Many seedlings he had raised were

brought by her to the flowering stage, and she very successfully continued the work he had begun until all keen lovers of Tulips and Irises found their way to Bobbingcourt while those plants were in flower.

"A handsome and gifted lady, she edited the book entitled *Notes on the Tulip Species* which her husband had in preparation at the time of his death. Not only so, but she illustrated the book with fifty-four coloured plates, all drawn and coloured by herself. Many Iris lovers received invitations to visit Bobbingcourt during the early days of the present week, but alas! the Lady of the Irises had passed from her garden, never to return." (From Mrs. Dykes's obituary in *The Gardener's Chronicle*, June 3rd, 1933.)

A short time later, a Professor Armstrong wrote a letter to *The Gardener's Chronicle* to add a word about the death of Elsie Katherine Dykes, the Lady of the Irises, which concluded: "There were no flowers at her funeral; nonetheless Irises everywhere breathed their silent prayer of grace, form, and charm of colour. Her memory is enshrined in the flower."

TULIPS BY ELSIE KATHERINE DYKES FOR HER HUSBAND'S BOOK *NOTES ON THE TULIP SPECIES.*

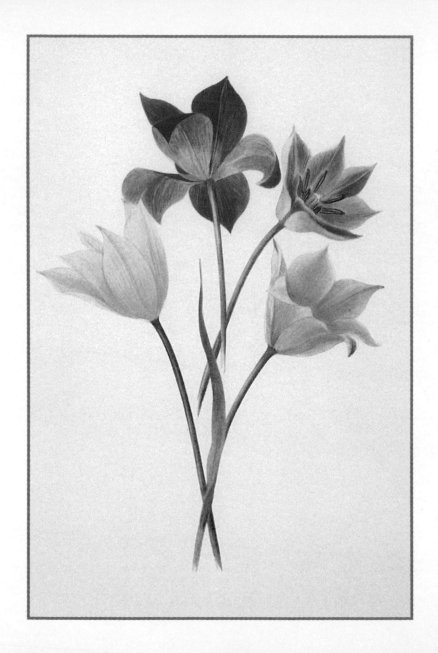

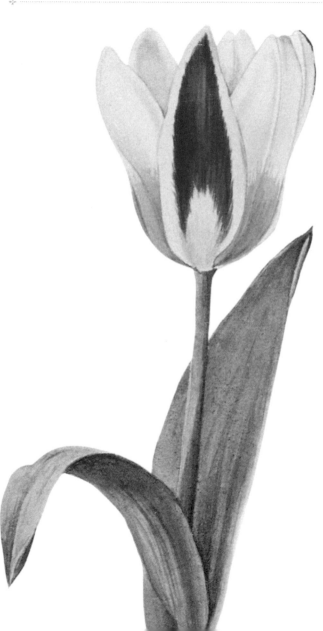

HERE AND FOLLOWING PAGES:
A PLETHORA OF TULIPS BY ELSIE
KATHERINE DYKES WHO EDITED
AND ILLUSTRATED HER HUSBAND'S
EXTRAORDINARY BOOK *NOTES ON
THE TULIP SPECIES.*

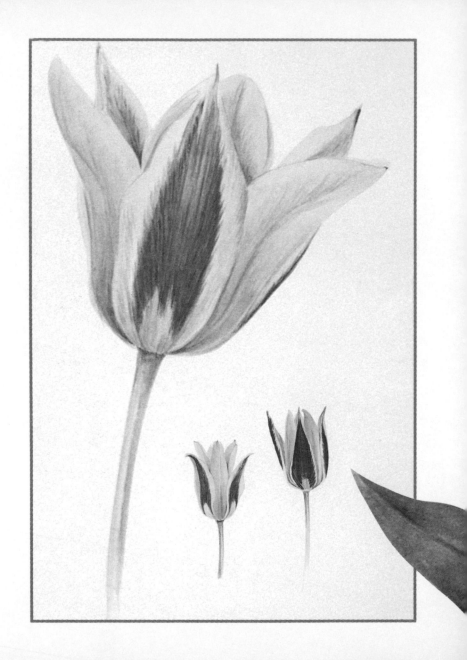

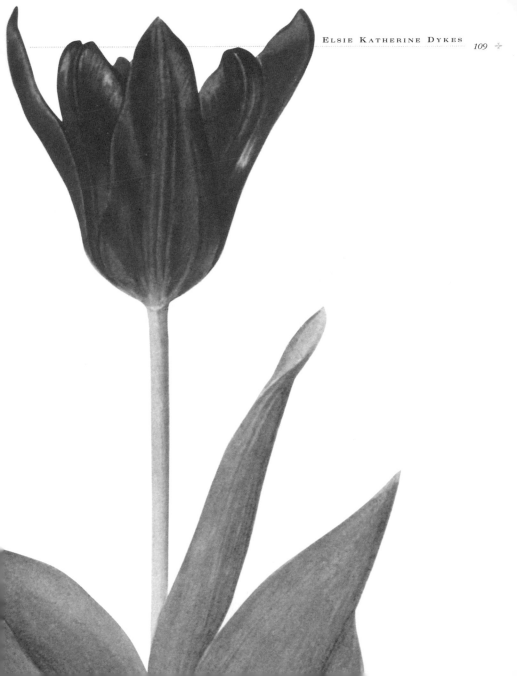

MARY EMILY EATON
(1873–1961)

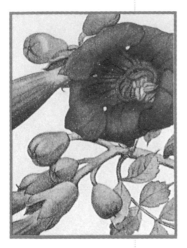

*M*ary Emily Eaton was born in England and studied drafting and watercolor as a young girl. Hired by the Royal Porcelain Works in Worcester, she created designs for china. Sometime later, while traveling in Jamaica, she began painting butterflies—a hobby that eventually changed the course of her life. On the strength of her butterfly illustrations, she was invited to work at the New York Botanical Garden in 1911. The job lasted for more than twenty years.

While employed at the Garden, Eaton worked for at least sixteen botanists who would ask her to draw paintings of the specimens grown at the Garden. More than 640 of her paintings were later published in *Addisonia*, a journal founded in 1916 to display full-color illustrations of vascular plants. Unfortunately, the printing quality of this volume was mediocre at best, and the reproductions failed to capture the lush and vivid colors of her original work.

According to a publication of the New York Botanical Garden, " . . . one cannot appreciate [Eaton's] impressive talents without seeing her originals. The work is confident and accurate, the colors fresh and clean. She worked quickly, often creating a painting in the morning, but her work never looks hurried."

In addition to her staff job at the Garden, Eaton painted

THOSE BEST QUALIFIED TO JUDGE REGARD MISS EATON AS THE GREATEST OF LIVING WILDFLOWER PAINTERS. SHE HAS NOT ONLY PAINTED THE LIKENESS OF FLOWERS WITH THE HIGHEST BOTANICAL ACCURACY, BUT SHE HAS BEEN ABLE TO PUT THE VERY SOUL OF THE PLANTS INTO HER PAINTINGS.
—*THE NATIONAL GEOGRAPHIC SOCIETY'S BOOKS OF WILDFLOWERS,* 1924

game birds, insects, and butterflies for the American Museum of Natural History and American wildflowers for the National Geographic Society.

During the Depression, in 1932 Eaton, like so many others, lost her staff position with the Garden and found it increasingly difficult to find employment elsewhere in the city. Although she continued to paint and look for work with publishers and galleries, there seemed little opportunity for her in America. In 1947 she returned to England, taking with her the majority of her paintings. Her publishing career seems to have ended after her return to England.

According to the New York Botanical Society, over 1,200 of Mary Emily Eaton's watercolor paintings and hundreds of her pen-and-ink drawings have been published. Her work was exhibited in 1922 and 1950 at the Royal Horticultural Society; the New York Botanical Garden in 1932; the New York Public Library in 1933; and the Hunt Institute for Botanical Documentation in 1976-77.

Though Mary Eaton worked in obscurity in America for most of her career, she was twice honored by her native country, awarded a silver Grenfell Medal from the Royal Horticultural Society in 1922 and again in 1950. Perhaps this is why she always retained her British citizenship and spent the last years of her life in England.

MARY EATON WORKED IN BOTH ENGLAND AND AMERICA AND EARNED HER LIVING DRAWING FLOWERS FOR PUBLICATION. THIS LOVELY TRUMPET CREEPER, *BIGNONIA RADICANS*, IS A FINE EXAMPLE OF HER EXCEPTIONAL TALENT. (COURTESY OF THE NATIONAL GEOGRAPHIC SOCIETY)

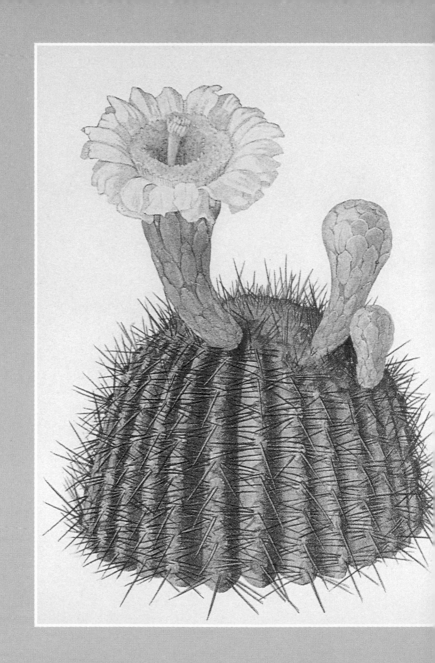

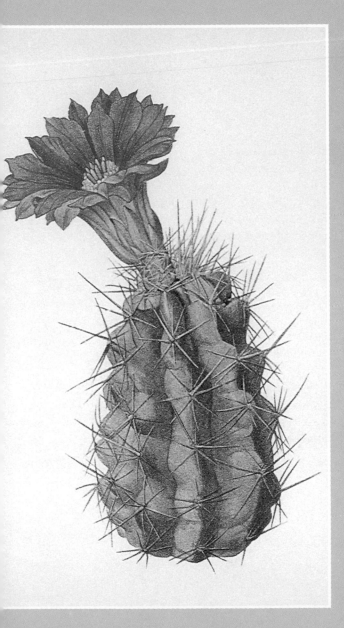

MARY EATON, WHO WORKED
AT THE NEW YORK BOTANICAL
GARDEN FOR A TIME, DID
MANY DRAWINGS FOR THE
WILDFLOWERS BOOK PUBLISHED
BY THE NATIONAL GEOGRAPHIC
SOCIETY IN 1924. (PHOTO
COURTESY OF THE NATIONAL
GEOGRAPHIC SOCIETY)

NATHALIE D'ESMENARD
(1798–1872)

*N*athalie d'Esmenard was born the illegitimate daughter of Joseph Etienne d'Esmenard and Jeanne Adolphine Kalegraber. When she was three years old, her parents married and soon had another daughter, whom they named Ines.

Joseph d'Esmenard had a career in politics before he died in a road accident in Italy. The family appointed Jean-Baptiste d'Esmenard to be a guardian of the two girls.

Nathalie eventually became a student of Redouté. Like many other ladies of her day, she learned flower painting from a master. An excellent student, d'Esmenard shows the influence of Redouté in design, color, and detailed botanical reference.

Her works were well received when shown at the salons of Paris in 1822 and 1827. She married Baron Antoine Renaud and signed some of her watercolors with her married name, Baronne Renaud. The baron died, leaving Nathalie a widow. In 1843 she married Pierre de Ricordy of Nice.

She lived in Nice until her death at the age of seventy-four.

The work of a truly exceptional artist, Nathalie d'Esmenard's exquisite drawings of camellias and roses are currently housed in the Broughton Collection at Fitzwilliam College, Cambridge.

RIGHT: A SPRAY OF FLOWERS BY
NATHALIE D'ESMENARD.
(COURTESY OF THE FITZWILLIAM
MUSEUM, CAMBRIDGE.)

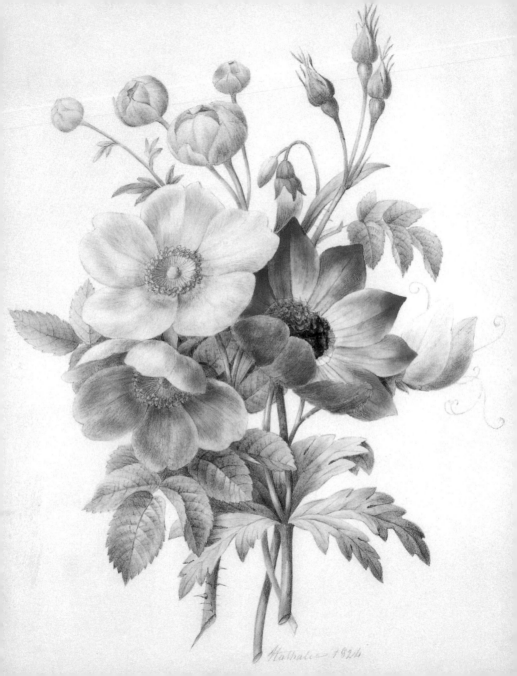

Nathalie 1824

MARY P. HARRISON
(1788–1875)

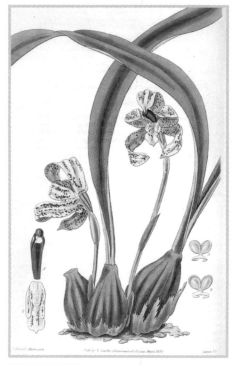

*orn in Liverpool, Mary Rossiter displayed an artistic talent from a very young age. Even as early as six years old, she was drawing, begging her parents for colors. However, she was discouraged from her passion, perhaps because she had an invalid mother who needed constant attention. Once, when she was a young girl, her father presented Mary with a book of colored prints, which she cherished for years.

She married young and honeymooned with her husband in France. The young Mrs. Harrison spent much of her time at the Louvre, copying paintings and studying her craft. The couple then returned to England where they lived quite well for a while.

However, within ten years, Mary's husband lost both his fortune and his health, and he became a burden to her. Needing to support him and their three children, she joined the Society of Painters in Water Colours Institute.

At the time there were few floral artists, and recognizing this deficiency, she astutely concentrated her talents in the fields of horticulture and botany. Harrison's innate sense of design and color, along with her talent for detail, made her the perfect practitioner of this kind of illustration. She became so proficient in her field that in France, during the reign of Louis Philippe, she was

ABOVE AND OPPOSITE: A TALENTED ARTIST, MARY HARRISON DID SEVERAL PLATES FOR *CURTIS'S BOTANICAL MAGAZINE*, INCLUDING THESE TWO GLORIOUS EXAMPLES OF THE *ORCHIDACEAE* FAMILY.

known as the Primrose
and Rose Painter. The
Queen of England
purchased two of
Harrison's paintings,
and because of such
honors, she also
enjoyed a popularity
among high social
circles. Harrison was a
contributor to *Curtis's
Botanical Magazine*.

Her two daughters,
Harriet and Maria,
grew up to become
excellent painters, and
her son was a profi-
cient landscape painter
though he died quite
young.

Mary's husband
died in 1861 and she
greatly mourned both
him and her son.
Known as a charming
and kind lady, Mary
Harrison continued
painting until her
death in 1875.

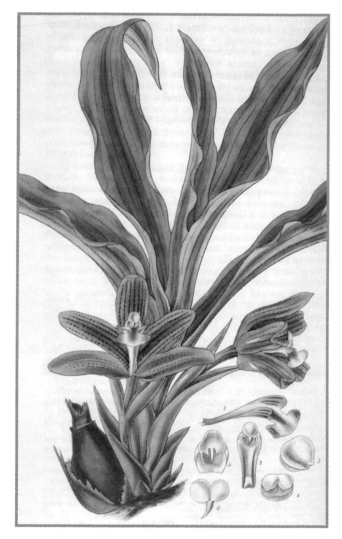

HENRIETTE GEERTRUIDA KNIP
(1783—1842)

*B*orn in Tilbury, Holland, on July 19, 1783, Henriette Geertruida Knip was the only daughter of Nicolas Frederick Knip the Elder, an artist well known for his landscape paintings. She and her two brothers received a thorough education in art from their famous father. While her brothers pursued landscape painting, following in the tradition of their father, Henriette devoted her talents to floral art.

The three siblings were quite competitive with each other, and perhaps Henriette chose floral painting as a way of distinguishing herself from the three accomplished male landscape painters in her family. Or perhaps she was innately curious about plants and flowers, as were so many women artists of her day. Whatever the cause, she pursued her calling with great passion and dedication.

As a young woman, she studied in Paris with Gerard van Späendonck, a well-known artist and one of the most highly respected teachers in Europe at the time. She obviously learned a great deal from the master, because her work improved enormously under his influence.

She developed a loyal following for her paintings, which were shown in France, Germany, Flanders, Amsterdam, and the Hague. There is no record that she ever married, and from all accounts she led a rather reclusive life, dedicated solely to art.

Henriette Geertruida Knip died in Haarlem in 1842, at the age of fifty-nine.

JANE WEBB LOUDON
(1807—1858)

*J*ane Webb was born at Ritwell House near Birmingham, England, in 1807 and was orphaned at the age of seventeen when her father, Thomas Webb, Esq , died in 1824. She later wrote that after her father's death "and, finding on the winding up of his affairs that it would be necessary for me to do something for my support, I had written a strange, wild novel, called *The Mummy*, in which I had laid the scene in the twenty-second century, and attempted to predict the state of improvement to which this country might possibly arrive." Published under a man's pen name, the book and its futuristic innovations caught the attention of John Loudon, a well-respected landscape gardener and writer.

In 1829 Loudon published a note in *The Gardener's Magazine*, referring to a steam plough Jane had included as one of her "hints for improvement." Loudon wanted to meet the author of *The Mummy*, whom he naturally assumed was a man. Jane later described their meeting. "In February, 1830, Mr. Loudon chanced to mention his wish (to know the author of *The Mummy*) to a lady, a friend of his, who happened to be acquainted with me, and who immediately promised he should have his wished-for introduction. It may be easily supposed that he was surprised to find the author of the book a woman; but I believe that from that evening he formed an attachment to me, and, in fact, we were

> IN 1832, MR. LOUDON COMMENCED HIS *ENCYCLOPEDIA OF COTTAGE, FARM, AND VILLA ARCHITECTURE,* WHICH WAS THE FIRST WORK HE EVER PUBLISHED ON HIS OWN ACCOUNT; AND IN WHICH I WAS HIS SOLE AMANUENSIS, THOUGH HE HAD SEVERAL DRAUGHTSMEN. THE LABOUR THAT ATTENDED THIS WORK WAS IMMENSE; AND FOR SEVERAL MONTHS HE AND I USED TO SIT UP THE GREATER PART OF EVERY NIGHT, NEVER HAVING MORE THAN FOUR HOURS' SLEEP, AND DRINKING STRONG COFFEE TO KEEP OURSELVES AWAKE.
> —JANE LOUDON, *THE COTTAGE GARDENER AND COUNTRY GENTLEMAN,* JULY 27, 1856

OPPOSITE: LOUDON'S SPRING BOUQUET BOASTS IRISES, SNOWDROPS, DAFFODILS, HEPATICA, POLYANTHUS, GENTIAN AND VIOLETS TO ENCOURAGE AND EDUCATE THE READER.

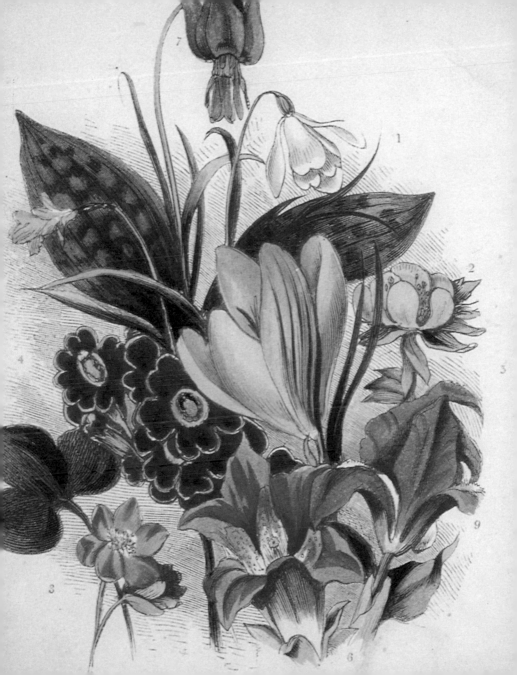

married on the 14th of the following September."
John Claudius Loudon was forty-seven
years old, twenty-four years older than his
bride, and his health was never very good, but
still they had a remarkable marriage. Their wedding
tour was idyllic, with trips
to the Lake District and
Scotland. Jane was a
dutiful wife to her hus-
band, who was quite famous
at the time for his books and
journals on gardening. She
knew little about the subject,
but she learned quickly. The
couple spent many hours
together in the garden,
growing roses and peonies
in great abundance. John
experimented with
plants for his writing. Jane
learned how to plant and
weed with a meticulous hand,
for John was a perfectionist
and a workaholic who
insisted that every plant be
labeled with its botanical name.
Acting as his secretary, copyist,
researcher, and note taker, Jane
assisted John with his monumental work,

Encyclopedia of Gardening, published in 1834.

Jane Loudon readily acknowledged that she knew little about gardening before she met her husband. She claimed that reading books on the subject was useless because they were too technical. Ever resourceful, Jane decided that a gardening book that could be easily understood by the general public was needed, and so she wrote *Instructions in Gardening for Ladies* in simple, clear language. She presented sensible and original ideas on how to garden, demonstrating why gardening was a fitting avocation for ladies and not all that difficult to master. Her book included personal sketches of and stories about gardeners—a casual approach that appealed to the public. An excellent botanical book, *Instructions in Gardening for Ladies* went through nine editions, selling upwards of 20,000 copies.

Part of Jane's understanding about gardening was due to the influence of John Lind-

ley, an important figure in horticulture who lectured regularly at the Royal Horticultural Society. He campaigned to get women interested in gardening. Jane attended his lectures and became one of his ardent followers. Lindley maintained that the garden was a woman's palette to paint, design, or embroider as she would a canvas, tapestry, or pillow. Jane often wrote about gardening using similar metaphors.

Unlike the ladies of her day, Jane Loudon continued working through her pregnancy in 1832. Until the day her daughter was born, Jane worked in the garden and helped her husband with his *Arboretum Britannicum.* This was an expensive project for the Loudons. The book was an enormous undertaking for the already frail John Loudon, and in the end, it cost him both his health and his wealth. By 1838, his health was declining and he was in severe financial debt.

About this same time, Jane began working on *The Ladies Flower Garden,* which would eventually be published in four volumes. Although it was not as financially successful as *Gardening for Ladies,* the book won her great acclaim. A review in *Gardener's Magazine,* volume 15 of 1839, declared that "as a drawing-book for young ladies to copy from, the work is unrivaled." Today, a copy of the work is extremely valuable.

Despite their financial problems and grueling work schedules, the Loudons were a very popular couple in their day. Considered among the leading authorities on horticulture, they were frequently invited to society dinner parties. They were friends of Charles Dickens and William Makepeace Thackeray. They traveled frequently to Manchester and Leeds to see the Botanic Gardens. In fact, they helped popularize the idea of

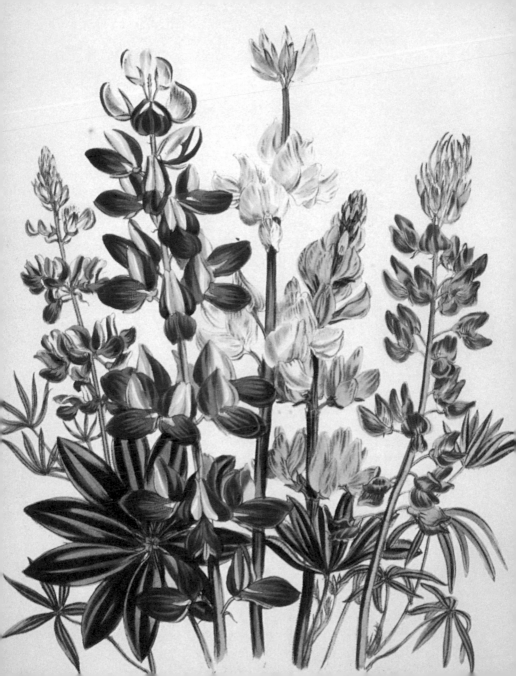

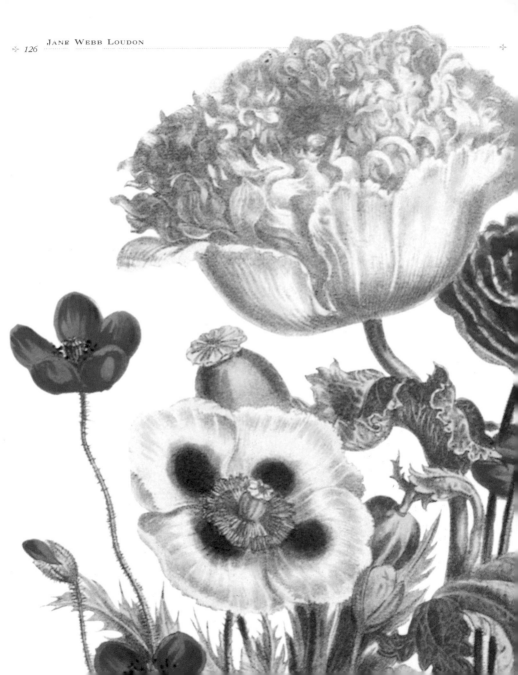

garden tours around the country.

Even when she traveled, Jane continued writing. She tried her hand at periodicals, issuing *The Ladies Magazine of Gardening* and the *Ladies Companion* in 1850 and 1851. Neither venture was successful, but she continued writing books. Extremely prolific, Jane wrote *Botany for Ladies* and was working on a second volume to the *Ladies Ornamental Flower Garden* when her husband became gravely ill with lung disease.

Almost penniless, John Loudon died at the age of sixty. Jane described his death in great detail in an article she later wrote about his life. "Soon after this he became very restless, and walked several times from the drawing-room to his bedroom and back again. I feel that I cannot continue these melancholy details; it is sufficient to say, that though his body became weaker every moment, his mind retained all its vigour to the last, and that he died standing on his feet. Fortunately, I perceived a change taking place in his countenance, and I had just time to clasp my arms around him, to save him from falling, when his head sank upon my shoulder, and he was no more.

"I do not attempt to give any description of the talents or character of my late husband as an author; his works are before this world, and by them he will be judged; but I trust I may be excused for adding, that in his private capacity he was equally estimable as a husband and a father, and as a master and a friend."

John Loudon's *Self Instructions for Young Gardeners* was published posthumously and included a memoir by

Jane about their life together. After his death, Jane received a small annuity of £100 from the Civil List "granted to her in recognition of the literary services rendered by herself and her husband." Still, she was in debt and left with a young daughter, Agnes, to support. Though Jane was only thirty-six years old and still a very attractive woman, she never remarried.

As an author, Jane Loudon was successful in part because she took every opportunity to turn her own life into books that held a personal appeal for her readers. *Lady's Country Companion,* for example, is an innovative book composed of a letter to a young married woman who moves from the city to the country. In it, Jane chronicles aspects of her own life and how she had felt when she made the same transition as a newlywed. When Jane and her daughter Agnes visited friends in France and fell in love with their host's clever pets, she wrote a book called *Tales for Young People,* which recounted these animal stories.

By 1848, Agnes was a beautiful young woman of sixteen who enjoyed parties and dances. Her extravagances depleted her mother's finances, and Jane was forced to take a position as editor of a periodical called *The Ladies Companion at Home and Abroad.* She spent two years working at the company before being asked to resign. By then, Jane Loudon's brilliant career had burned out and she struggled through her final years. She died in 1858 and was buried next to her beloved husband.

Her talents were passed along to her daughter. Agnes Loudon went on to write several children's books and various stories for publication.

PLATE II.

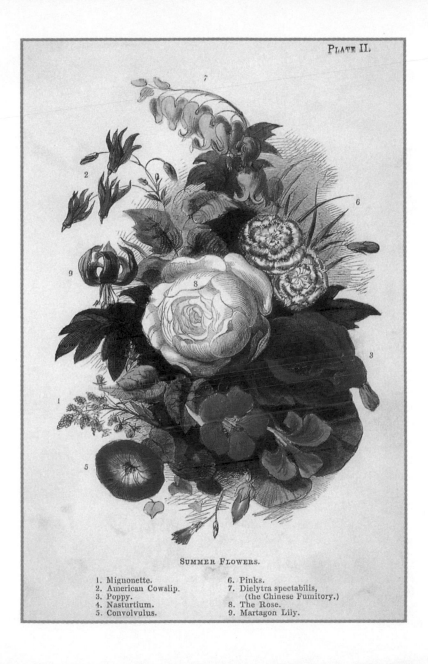

SUMMER FLOWERS.

1. Mignonette.
2. American Cowslip.
3. Poppy.
4. Nasturtium.
5. Convolvulus.

6. Pinks.
7. Dielytra spectabilis,
 (the Chinese Fumitory.)
8. The Rose.
9. Martagon Lily.

THE MISSES MAUND
(c. 1800s)

*B*enjamin Maund was a well-respected publisher of botanical periodicals. During the 1820s and 1830s, he produced *The Botanic Garden* and *The Botanist*. Both were considered among the very best botanical publications of their day.

While he received all the credit for these publications, many of the illustrations in them were done by women. Whether Maund hired women because they were talented or because they worked much cheaper than men is unknown. Still, he had a fine eye for choosing artists. Mrs. Withers contributed one hundred of the 250 plates in *The Botanist;* other women who appeared in his publications were Miss Jane Taylor and Mrs. Edward Bury.

Among his finest contributing artists were Maund's two daughters. Almost nothing is known about these talented women; even their exact names remain a mystery. Their work was signed variously as Miss Maund or Miss S. Maund.

These two skilled artists were obviously dedicated to the art of botany and could not have drawn plants so accurately without study, diligence, and training. Most probably, the Misses Maunds were well sequestered in household activities and received formal training in botany from their famous father.

Neither daughter ever married; yet both left a glorious legacy of art, valued even more today than it was one hundred and fifty years ago.

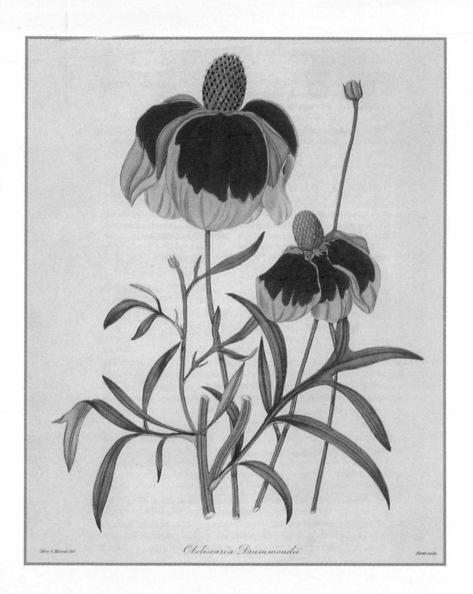

Obeliscaria Drummondii.

Verbena incisa.

Nemophila aurita.

Genista triquetra.

Tropæolum tuberosum.

OPPOSITE AND THIS PAGE: Miss S. Maund (her first name is not known) had a fine and delicate hand at drawing flowers, as is evident in all of her work.

Bartonia aurea.

Orobus pisiformis.

Gladiolus floribundus.

Nemophila insignis.

Chrysanthemum Sinense.

Phacelia congesta.

Berberis empetrifolia.

Rudbeckia asperula.

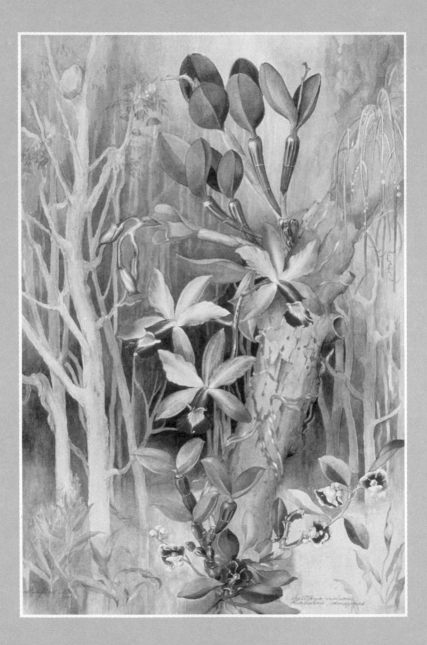

MARGARET MEE
(1909–1988)

Margaret Mee is certainly the most contemporary woman of flowers included in this book. Her work was published in another century from that of most of the artists mentioned here, and Mee consequently represents a bridge between the Victorian and the contemporary artist. Her work was so exceptional that it is impossible to talk about female botanical artists without mentioning this extraordinary woman who lived and worked in ways that were denied her Victorian sisters.

OPPOSITE: THIS ILLUSTRATION OF AN ORCHID WAS DONE DURING ONE OF MARGARET MEE'S TRIPS TO THE AMAZON. (COURTESY OF THE ROYAL BOTANIC GARDENS, KEW)

Margaret Ursula Mee was born on May 22nd, 1909, in Chesham, Buckinghamshire, England. She grew up in a modest home, surrounded by nature in the Chiltern Hills. Even the nearest school was too far away for her to attend, so she was instructed at home. Much of her teaching came from her mother's sister, Ellen Mary Churchman, an illustrator of children's books who lived with the family for long periods of time.

During the war, with her father off fighting, Margaret and her siblings were settled in Hove, near Brighton, and attended a small school. After her father returned home, in 1922, when Margaret was thirteen, the family moved back to Chesham and Margaret was sent to school in Amersham, where her artistic talents began to surface.

Margaret's father was an avid naturalist, and he encour-

aged her to pursue her love of nature, helping her learn the names of wildflowers. In 1926, she was enrolled at the School of Art and Science in Waterford. She earned a teaching degree and got a job in Liverpool, but she started to travel in 1932 and eventually moved to Germany. Traveling would always be a major part of Margaret Mee's life. She moved back to London in the 1930s, after witnessing the atrocities against the Jews in Germany.

She married Reg Bartlett, but this marriage was not very successful. When her father died, she joined her mother in France, which she so loved that she stayed there after her mother returned to England.

As Britain prepared for World War II, Margaret did her part to help. In 1945, when the war ended, she decided to pursue a career in art and entered St. Martin's School of Art in London. She was an excellent student and was recommended to the Camberwell School of Art in 1947, which she attended on a grant. While still in school she met and married Grenville Mee, a commercial artist from Leicester.

In 1952, Margaret and her husband traveled to Brazil to visit Mee's sister, Catherine, who was quite ill (she later returned to England, where she died). It was this trip that started Margaret's extraordinary career in botanical illustration. In Brazil, Margaret Mee discovered the wildlife of the Amazon, where she spent the next thirty-five years, capturing images to share with the world.

For five years, she taught commercial art in São Paulo's British school, St. Paul's. Her first exhibit of botanical illustrations at São Paulo's Instituto de Botanica led to a contract to

work there. In 1959 an exhibit of her paintings was featured at the 150th anniversary celebration of the Jardim Botanico, Instituto de Botanica, Rio de Janeiro. In 1960 an exhibition of her work at the Royal Horticultural Society earned her the Grenfell Gold Medal.

To make her drawings, Mee traveled into the Brazilian jungles to collect specimens and paint portraits *in situ* of the tropical flora. She traveled in a dugout canoe with a native guide and lived in the jungle, eating packets of dehydrated soup boiled in swamp water. She once told a reporter that her husband tended "to get rather fed up when I go away into the jungle for two and three months at a time."

Over the course of thirty-five years in Brazil, Margaret Mee wrote and illustrated three books and executed numerous paintings of the flora and fauna of this tropical region. She was awarded the M.B.E. in 1976, as well as several other prestigious awards. She contributed some of the world's finest flower drawings in a style that was entirely original. And unlike so many of the other women in this book, she was repeatedly recognized and applauded for her contributions to the field of botanical illustration.

MARIA SIBYLLA MERIAN
(1647—1717)

*M*aria Sibylla Merian, the child of a Swiss father and a Dutch mother, belonged to a very talented family of engravers and painters. Her father, Matthew Merian, the son of a magistrate of Bâle, was an artisan of aquafortis engraving, a newly invented branch of art. Her mother was the daughter of John Theodore de Bry.

Maria was born in Frankfurt in 1647. Inheriting her father's artistry, she soon excelled in painting and drawing. Her much older brother, Matthew, was a successful painter who no doubt contributed to Maria's artistic education. Maria's father died when she was just a child, and her mother married James Morell, an accomplished Dutch painter. Morell adored Maria and spent hours teaching and schooling her in the arts. At first Maria devoted her time to miniature paintings, but she became fascinated with insects and began studying them obsessively. She collected insects, traced and colored them. Her mother attributed Maria's fascination to the fact that during her pregnancy, she herself had collected caterpillars, beetles, and butterflies. She tried to discourage Maria from this "unladylike pursuit," but her stepfather encouraged Maria to follow her natural inclinations. No doubt this paternal support accounted for Maria's great confidence and stunning independence in later years.

> MARIA SIBYLLA MERIAN WAS CERTAINLY ONE OF
> THE FINEST BOTANICAL ARTISTS OF HER TIME.
> —WILFRED BLUNT, *THE ART OF BOTANICAL
> ILLUSTRATIONS*

Maria was sent to study with Abraham Mignon and Johann Graff of Nuremburg, famous artists of the time who were friends and students of her stepfather. She became Graff's pupil in 1664 and married him in 1668, when she was eigh-

teen years old. He was a talented flower painter who had published a catalog of plants in 1641. The marriage did not prove to be fortunate. In the beginning, surrounded by artists and engravers, Maria was quite happy in Nuremberg, but then her husband's affairs turned unsavory and he was obliged to leave the country. As a consequence, Maria decided to drop her married name and became known forever after by her maiden name. The dilemma of being alone and needing money strengthened Maria's determination to be independent, a role quite unusual for women in the late 1600s. She earned money with her embroidery. It was said that she had as much skill with a needle as she did drawing. To make money and to encourage women in

embroidery, she published a book that included designs. Maria also painted portraits on commission. However, insects were what really interested her, and she continued studying them.

In 1679, the first of her three volumes on European insects was published. Volumes two and three appeared in 1683 and 1677 respectively. She also executed drawings for books and hand-colored them. Many of her works depict beautifully drawn plants as well as insects. In fact, Merian was the first artist to depict insects in their natural habitat, a practice that has since become commonplace. The field of entomology was in its infancy at this point, and so Merian's work does include some errors, such as the place-

ment of insects on incorrect plants. Still, the quality of her work and her groundbreaking techniques were formidable.

In 1680 Merian published *Neus Blumen Buch*, a book of exquisite garden flowers illustrated with hand-painted engravings, used as patterns for embroidery. In 1685, after seventeen years of marriage and the birth of two daughters, she left her husband for good. She became an advocate of Labadism, an exclusive sect founded by the French pietist leader Jean de la Badie, who rebelled against the church of Rome and had numerous followers, many of them women. Merian took her two daughters with her to Bosch, where they lived on a commune. Her husband tried in vain to persuade her to return to him.

While in Bosch, Merian examined the extensive insect collection of M. Sommerdyck, rekindling her passion for entomology. She discovered a group of tropical insects that had been brought back from Surinam; she drew these insects from dried specimens, although this was not the way she preferred to work. She visited museums in Amsterdam that had collections of insects. Encouraged by Nicolas Witesan, the director of the East India Company, and others, she decided to study insects in their native habitat. She set sail with her daughters in 1698, bound for South America, a perilous journey at best. "It was a kind of phenomenon," Réaumur, the French physicist and naturalist, wrote at the time, "to see a lady actuated by a love of insects so truly heroic, as to induce her to traverse the seas for the purpose of painting and describing them."

Remarkably determined, Merian and her two daughters made their way to Surinam (Dutch Guinea), and their efforts

OPPOSITE: ANOTHER FINE EXAMPLE OF MARIA SIBYLLA MERIAN'S EXTRAORDINARY WORK. (COURTESY OF HARVARD UNIVERSITY, HOUGHTON LIBRARY)

were rewarded. In the tropical climate, Merian discovered many new insects and plants. For two years, she devoted all her time to drawing and delineating insects in their living states, ever conscious of how little was known in this burgeoning branch of natural science.

Unfortunately, Merian's health suffered from the oppressively hot climate, and she had to leave Surinam in 1701. Her daughter Johanna stayed in South America and continued drawing indigenous insects. Maria and Dorothea returned to Europe, where Maria exhibited her drawings to much acclaim. She was urged to publish the plates, but the expense of such an undertaking delayed publication for many years. Meanwhile, she sent Dorothea to America for additional material. Merian's monumental work, *Metamorphosis Insectorum Surinamensium*, was published in 1705. The costly volume contained sixty plates.

Reviewing the book almost one hundred and fifty years later, in the 1843 edition of *The Naturalists Library,* volume VII, Jardine wrote that Merian's pictures "have not been surpassed by any works of art of a similar description, by the moderns, to whom her method of arranging and combining her figures may serve as a lesson. Her manner of introducing the insects in their various stages of metamorphosis, in connexion with the plants upon which they feed, is, in our opinion, not only very instructive but extremely elegant, and her skill in composition has almost invariably led her to do this in an artist-like pleasing way."

Merian's later years were spent preparing a Dutch edition of the first two volumes of *The Wonderful Transformation of*

Caterpillars and their Singular Plant Nourishment. She was
working on twelve drawings for publication when she died of
a stroke in 1717, at the age of seventy. These new designs
were added to an edition of *Metamorphosis Insectorum Suri-
namensium* that was published in 1719 by her daughter
Dorothea. Another edition appeared in the Hague in 1726 with
text in Latin, French, and Dutch. The fourth edition was con-
sidered the most inferior. Another work occasionally referred
to as one of Merian's is *Historiae des Insects de l'Europe
desines d'apres nature et expliques par M. S. Merian,* translated
into Dutch and French in 1740. Supposedly new, the work
was really a reprint of *Erucarum ortus, ailmenta et parudox
metamorphosis* with some editions and alterations.

Today, Merian is considered one of the most gifted women
of her generation, even though she has never achieved the
fame warranted by her work. In the 1976 edition of
Women Artists, published by the Los Angeles
County Museum of Art, Merian is cited as
"certainly one of the major artists of
this genre [who] deserves to be as
famous as Redouté and Audubon."

Merian's works now hang in
museums around the world from
Minneapolis to Leningrad. In 1987, a copy of the sec-
ond edition of *Metamorphosis Insectorum Surinamensium*
and another Merian work, *De Europische Insecten,* sold at auc-
tion at Sotheby's for £121,000.

HENRIETTA MARIA MORIARITY

(FLOURISHED 1800)

*U*nfortunately, very little is known about the life of Mrs. Moriarty. In the *Journal of Botany, British and Foreign,* issued in 1917, Robert Hardwicke writes that no biographical information regarding her is procurable. "Of the author Mrs. Henrietta Moriarty, we know nothing beyond what may be gathered from the *Viridarium* except that in 1812 she published in London '*Crim. Con.: A Novel Founded on Facts,*' the title is hardly what would have been expected from an author who seems to have been engaged in educational work."

Biographers have speculated that Moriarty may have worked as a governess to families of position. They deduce this principally because her book, *Viridarium: Coloured Plates of Green-House Plants, with the Linnaean Names and with Concise Rules for their Culture,* listed subscribers such as "His Royal Highness the Duke of Sussex, 2 copies," and the Dowager Lady de Clifford. Writing from a rather lofty position, Moriarty states in her preface to the *Viridarium* that "This work is intended for those who take delight in plants, but have not the advantage of a gardener who understands them."

The second edition of the book was retitled *Fifty Plates of Green-House Plants* and was published in 1807. In her introduction, she espoused a fairly common morality of the day, praising flowers for their religious and moral significance. "Another object which I flatter myself I have in view, without presumption," Moriarty writes, "is that I may sometimes lay the foundation of a taste for the most refined pleasure that the field or garden can afford, and at the same time, instill an

early conviction of the wisdom in
which are made the manifold works
of the Supreme Being."

Yet there was a problem for Mori-
arty, and others, who studied botany.
Flowers also had a sexual connota-
tion that both titillated and shocked
Victorian women. The concept of
reproduction in natural history
posed a great conflict for these
prim and proper matrons.

Linnaeus's classification of
flowers by stamens and pistils,
with their obvious sexual function, couldn't be
ignored if women were to consider themselves true
students of the field. The moral implication was
appalling to any proper Victorian, especially Henri-
etta Moriarty, and she said so in no uncertain terms.
In *Fifty Plates of Green-House Plants*, she postulates
that the study of the Linnaean system was dangerous to
the young. She warned that "those who have the instruc-
tion, or I might say, the formation, and even the fashioning
of young minds most at heart, often find it difficult to obtain
representations in this most pleasing branch of natural history;
on the one hand sufficiently accurate, and, on the other,
entirely free from those ingenious speculations and allusions,
which, however suited to the physiologist, are dangerous to
the young and ignorant: for this reason I have taken as little
notice as possible of the system of the immortal Linnaeus,

and of all the illustrations and comments on it; nay, I have not once named the fanciful Doctor Darwin, and, having no desire to extenuate the merit of any writer, or to supersede the use of his labour, it will be pleasure and satisfaction enough for me if my own performance shall prove such a one as the rising generation can consult with safety and advantage."

Though little can be said about the life of the artist, her ideas and passionate beliefs are apparent in her work. Though it may seem awkward and primitive in our day, her approach was the norm for her day and age. Still, Moriarty's art is anything but dated. The exquisite plates in her book reveal a fine hand and a delicate sense of color and, despite her outdated ideas, her art survives intact and quite gloriously.

ABOVE: MORIARTY COMPLAINED ABOUT THE TEDIUM INVOLVED IN ILLUSTRATING SUCH A COMPLEX PLANTS AS THIS FINELY DRAWN *AGAPANTHUS.* OPPOSITE: ALTHOUGH PRIMARILY A BOTANY BOOK, MORIARTY'S WORK WAS ALSO A PRIMER FOR YOUNG LADIES, WHO WANTED TO DRAW FLOWERS SUCH AS THESE.

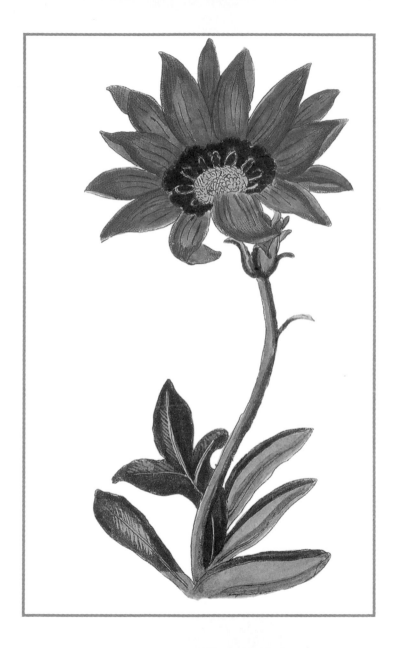

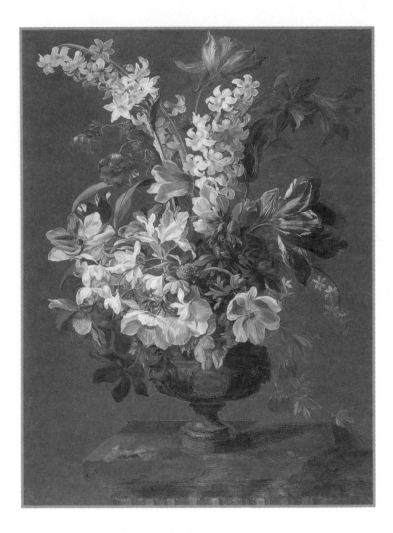

MARY MOSER

(1744—1819)

ary Moser was an only child, the daughter of a Swiss portrait painter who settled in England in the mid-eighteenth century. In 1769, her father, George Moser, was elected Keeper of the Royal Academy and taught painting to George III, among others. Consequently, Mary was surrounded by art and artists from earliest childhood. Even as a young girl, she showed promise, winning amateur prizes for her artistic abilities.

At twenty-four, Mary Moser was elected as a founding member of the august Royal Academy. While other artists concentrated on landscape painting, Mary became known for her magnificent flowers. A regular contributor to the Academy, Mary was asked by Queen Charlotte to paint a room at Frogmore in Windsor Park, which became known as "Miss Moser's Room."

In 1797, when she was fifty-three years old, she married for the first time. Sadly, her husband, Captain Hugh Lloyd, died four years later.

Perhaps more tragically, Moser began losing her eyesight shortly after her marriage and was forced to give up painting. She died in 1819, at the age of seventy-five.

CLARA MARIA POPE
(1768–1838)

OPPOSITE: CURTIS'S
MONOGRAPH OF CAMELLIAS
IS A COLLECTOR'S ITEM WITH
FINE PLATES BY CLARA MARIA
POPE. (COURTESY OF THE
ROYAL BOTANIC GARDENS,
KEW)

Clara Pope was born into an artistic family. Her father, Jared Leigh, was an amateur artist. A beautiful young girl, Clara was an artist's model for many years, working regularly for the painter Francis Wheatley. While still very young, she married Wheatley and they soon had three daughters. During this time, Clara, like many artists of her day, painted miniatures. In 1796, she began exhibiting her work at the Royal Academy.

Wheatley died suddenly in 1801, and to support her family, Clara struggled at odd modeling jobs. She continued to paint, and her watercolors came to the attention of Mr. Curtis, the publisher of the *Botanical Magazine*. Clara had a fine sense of color and a great talent for arranging flowers on a page. Eventually, Curtis asked her to work on his famous *Monograph of Camellias*.

In 1867, she married the actor Alexander Pope, becoming his third wife. She was a well mannered, beautiful woman who enjoyed a wide circle of friends. She became a painting teacher and her students included Princess Sophia of Gloucester, the Duchess of St. Albans and other such prominent people. She was

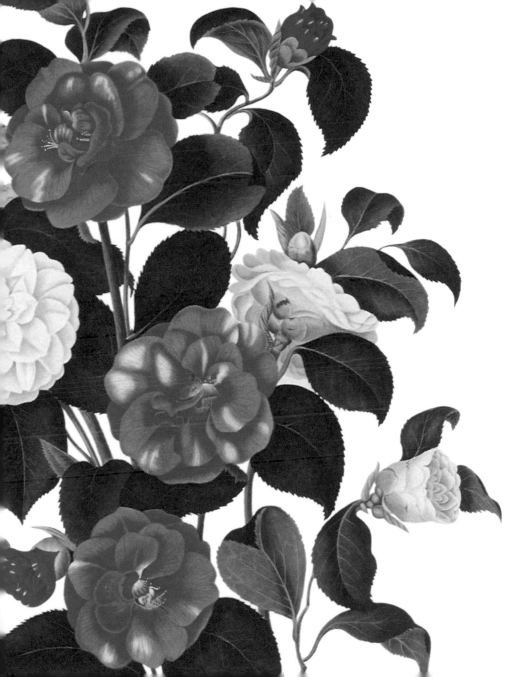

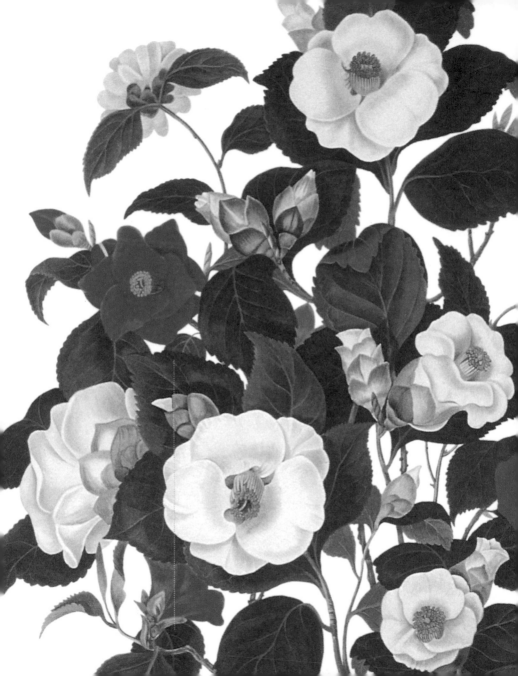

embraced by high society for her great charm and talent.

Clara Pope also painted portraits. In 1812, she executed a full-length portrait of Madame Cataline, which was enormously popular. She could have easily accepted other portrait commissions, but she pursued her floral watercolors instead.

Pope's work was not just lovely, it was always botanically accurate as well. Therefore, it is a great surprise that Clara Pope's name has faded with time. Virtually forgotten, Clara Pope seems to have disappeared from the annals of botanical illustration. Yet her work remains as vibrant, fresh, and detailed as that of any other great botanical illustrator of the nineteenth century.

OPPOSITE: ANOTHER OF POPE'S CAMELLIA PORTRAITS. (COURTESY OF THE ROYAL BOTANIC GARDENS, KEW)

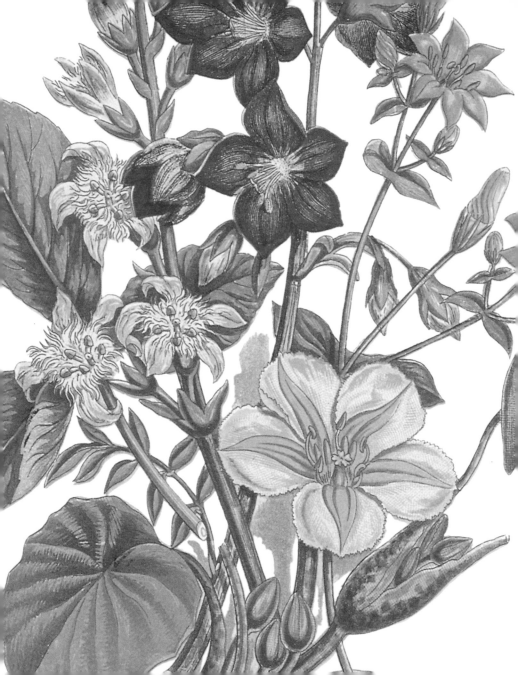

ANNE PRATT
(1806–1893)

*A*nne Pratt was one of the more successful botanical artists of her gender and time. She was born on December 5th, 1806, in Stroud, Kent, the second of three daughters of Robert Pratt, a grocer, and Sara Bundock. Her mother was a great gardener and instilled a love of plants and flowers in her young daughter.

A frail child, Anne devoted much of her time to studying instead of playing childhood games. Consequently, she became quite learned in literary matters. She was educated at Eastgate House, near the Rochester Museum. Because she seemed such a lonely child, a Scottish friend of the family, Dr. Dodds, introduced her to botany. She was instantly enthralled with the subject. Her older sister encouraged Anne's interest by collecting plants and flowers and bringing them back to the house. In this way, Anne accumulated a fine herbarium and continued to sketch and study plants as she grew older.

In 1826, when she was twenty years old, Anne Pratt left home and moved to Brixton to live with friends. There, she tried to get her work published. It took her several years before her first book appeared in print. *Flowers and Their Associations*, published in 1828, contained beautiful illustrations drawn by Pratt and sold very well. Her next book, *The*

> THE FOLLOWING PAGES ARE INTENDED CHIEFLY FOR THE INFORMATION AND AMUSEMENT OF THOSE WHO, WHILE FOND OF FLOWERS, HAVE NOT MADE THEM THE OBJECT OF THEIR STUDY. SEVERAL INTERESTING CIRCUMSTANCES RESPECTING FLOWERS ARE HERE RECORDED; AND THE GENERAL OBSERVATIONS ON THEIR HABITS AND NATURE, WHICH AN ACQUAINTANCE WITH BOTANY HAS ENABLED THE AUTHOR TO FURNISH, ARE EXPRESSED IN A MANNER WHICH, FROM ITS GENERAL AVOIDANCE OF SCIENTIFIC TERMS, SHE HOPES WILL RENDER HER WORK PLEASING TO THE GENERAL READER.
>
> —ANNE PRATT, PREFACE, *FLOWERS AND THEIR ASSOCIATIONS*, 1840

OPPOSITE: A GARLAND OF FLOWERS BY ANNE PRATT DISPLAYS HER WONDERFUL SENSE OF COLOR.

Field, the Garden and the Woodland, was published a short time later. Her glorious illustrations were botanically accurate and she became quite a popular illustrator and author. When her book about botany, *Wild Flowers,* was published, the colored block prints by W. Dickes, created from Anne's original botanical studies, quite impressed Queen Victoria.

A prolific writer and artist, Anne Pratt also published *Garden Flowers of the Year.* In 1849, she began work on one of her most extensive projects: five volumes of *The Flowering Plants, Grasses, Sedges and Ferns of Great Britain* (1855-66). These volumes were readily accepted by the public because of their accurate, clear, and precise writing, as well as their winsome paintings. Interspersed throughout the text and drawings are delightful anecdotes about plants.

A seemingly tireless artist, Anne next published *The Ferns of Great Britain and Their Allies.* In total, Anne Pratt wrote and illustrated approximately twenty books dealing with botany. Pratt wrote especially for young people, but her books were read by a wide audience. As a writer, she had the ability to blend botany with the romance of nature and thus fulfill two marketing niches—the demand for nature writing and flowers and the need for botanical knowledge for ladies. But most important, her books were loved for their fine illustrations.

In 1866, at the age of sixty, Pratt married John Pearless of East Grinstead, Sussex, and eventually moved to Shepherds Bush, London. There she practiced plant therapy and wrote popular romantic flower lore for contemporary women's magazines.

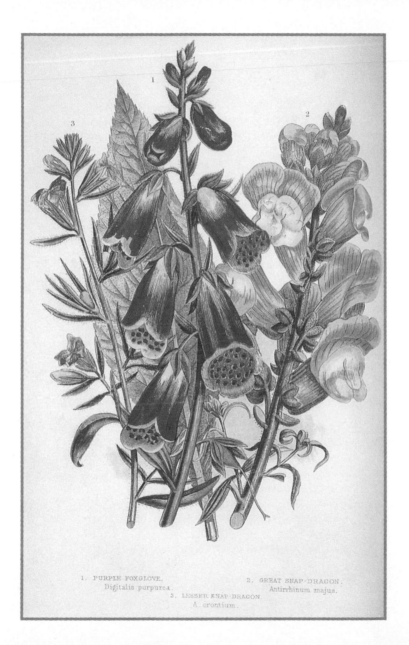

1. PURPLE FOXGLOVE,
Digitalis purpurea.

2. GREAT SNAP-DRAGON,
Antirrhinum majus.

3. LESSER SNAP-DRAGON,
A. orontium.

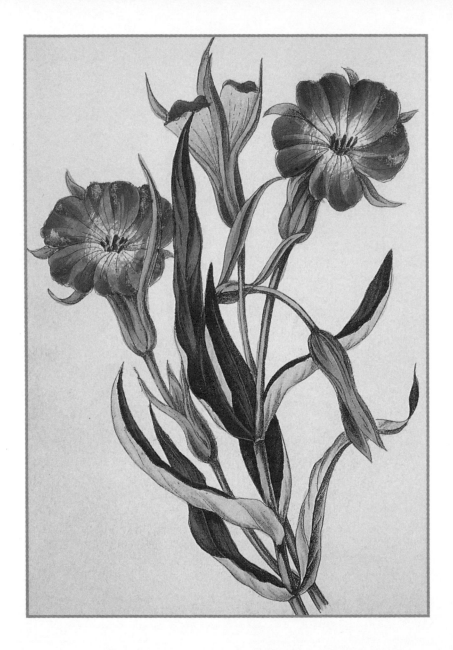

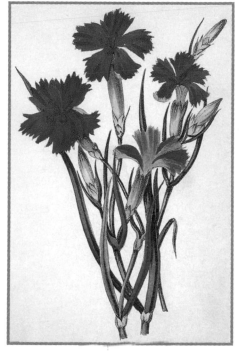

Though she was certainly more successful than most of her contemporaries, she did not escape her share of controversy. There have been many arguments over whether or not Pratt should be considered a true botanist. The *Journal of Botany*, where some of her works appear, states that although she was an excellent artist, she lacked the scientific credentials to grant her the appellation. James Britten, a biographer of British botanists, goes even further when he insists that "her work is meager and incomplete." Clearly she was a woman of great talent, and she displayed a profound knowledge of botany. Her works should speak for themselves. Her books constituted a major contribution to the advancement of flower study, especially among the general public. All of her books are well composed, with handsome, accurate illustrations. Yet, like so many of her contemporaries, she too was unfairly criticized for her work. In 1950, Wilfred Blunt wrote in his *The Art of Botanical Illustration* that, "The plates in

OPPOSITE: THE FRONTISPIECE, A *NICOTIANA*, TO *FLOWERS AND THEIR ASSOCIATIONS* BY ANNE PRATT.

ABOVE: A FINE EXAMPLE OF *DIANTHUS* AS TAKEN FROM *FLOWERS AND THEIR ASSOCIATIONS*, CONSIDERED ONE OF ANNE PRATT'S FIRST WORKS.

LEFT: AN EXCELLENT ILLUSTRATOR AND A FINE WRITER, ANNE PRATT WROTE MANY SUCCESSFUL BOOKS. THIS PARTICULAR BOUQUET IS FROM *FLOWERING PLANTS, GRASSES, SEDGES AND FERNS OF GREAT BRITAIN*.

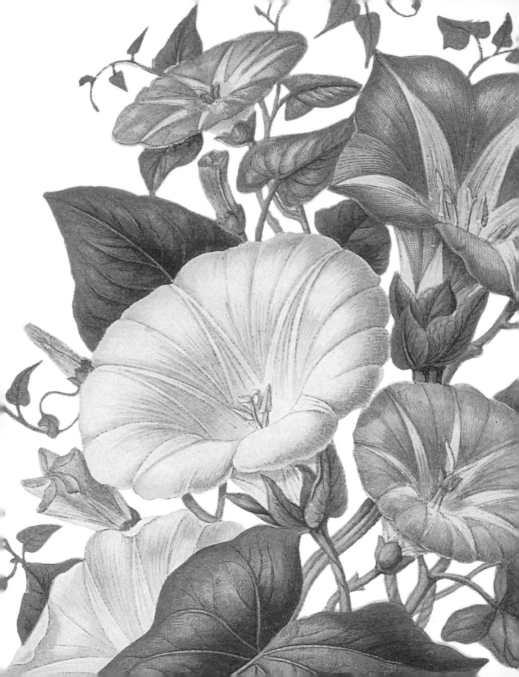

Anne Pratt's *The Flowering Plants and Ferns of Great Britain* . . . are pleasantly composed, though owing to the newly popular technique of chromolithography, not very accurate in color. . . . The drawings which illustrate her book are her own work, though in their published form no doubt owe a good deal to the artists of the firm W. Dickes and Co. who redrew them on stones." This was truly an unfair attack on a very gifted artist.

Anne Pratt died in London at the age of eighty-seven. Even today, her work continues to intrigue and excite collectors of botanical illustration.

OPPOSITE: CONVOLVULUS FLOWERS, MORE COMMONLY KNOWN AS BINDWEED, FROM ANNE PRATT'S *FLOWERING PLANTS, GRASSES, SEDGES AND FERNS OF GREAT BRITAIN.* BELOW: A VARIETY OF FLOWERS BY ANNE PRATT.

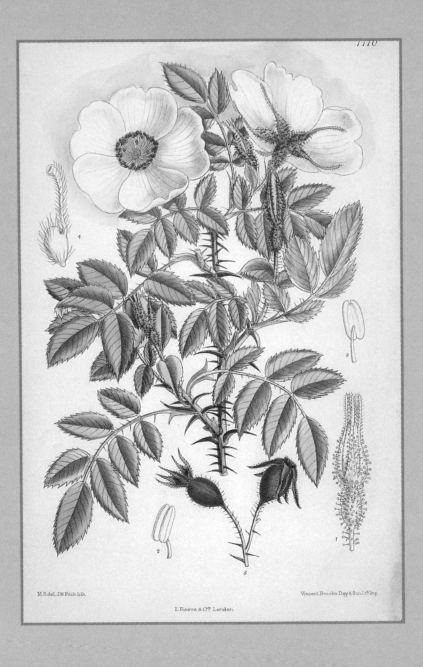

M.S. del. J.N. Fitch lith.

Vincent Brooks Day & Son Ltd Imp

L. Reeve & Co. London.

MATILDA SMITH
(1854–1926)

orn in Bombay, India, in July 1854, Matilda Smith emigrated to England when she was very young. She had very little botanical training as a child, yet always displayed a natural curiosity about plants. This interest was encouraged by her second cousin, Sir Joseph Dalton Hooker, the father of Lady Thiselton Dyer, an accomplished botanical artist.

In 1877, at the age of twenty-three, Smith joined the Royal Botanical Gardens at Kew. She was a great admirer of W. H. Fitch, the chief illustrator of *Curtis's Botanical Magazine,* and although Smith felt she could never attain Fitch's standards, Sir Joseph Dalton Hooker encouraged her to submit her work for publication. Her second cousin spent many hours working with her. In 1878, she contributed her first drawing to *Curtis's Botanical Magazine.* From 1879 to 1881, she contributed almost twenty or more plates to every issue. By 1887, Smith was practically the only artist working for the periodical. Although she received almost no recognition, she contributed more than 2,300 drawings to the magazine during a career there that spanned almost forty-four years. Finally, in 1898, she was appointed the sole official artist for *Curtis's Botanical Magazine.*

Smith was so talented that Sir Joseph Dalton Hooker included her work in his *Iconeas Plantarum.* He used work that she had provided for the *Transactions of the Linnaean Society*, and the *Transactions of the Royal Society and the Kew Guild,* about 1,747 illustrations in total.

OPPOSITE: ONE OF MATILDA SMITH'S DRAWINGS FROM *CURTIS'S BOTANICAL MAGAZINE* THAT SHOWS DETAILS OF THE PARTS OF A PLANT.

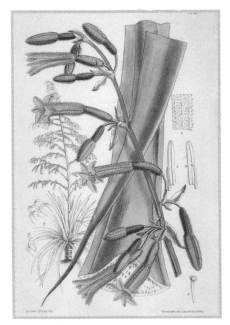

ABOVE: A *BESCHORNERIA
WRIGHTII*, KNOWN TODAY AS
AGAVE.

ABOVE RIGHT: AN ILLUSTRATION
OF PONDWEEDS THAT MATILDA
SMITH PUBLISHED IN
*POTAMOGETONS OF THE
BRITISH ISLES*.

OPPOSITE: AN ORCHID,
HABENARIA.

In 1916, Smith was appointed President of the Kew Guild, an office she graciously accepted as an honor. In November 1921, she was elected an Associate of the Linnaean Society of London and awarded the Silver Veitch Memorial medal. Never married, she was known as a very charming woman who had a great many friends.

Smith retired in July 1921 and died five years later, at the age of seventy-two. Her well-attended funeral was held on New Year's Day in a service at Kew Church, and she was buried in Richmond Cemetery.

Thirty years after her death, Wilfred Blunt, in his classic *Art of Botanical Illustration*, severely—and unfairly—criticized the work of Matilda Smith. "Miss Smith, like Mlle. Basseport," Blunt wrote, "remained to the end a rather fumbling draftsman, more remembered for her 'great pains' and 'untiring efforts' than for her skill, but best of all esteemed for the charm of her personality." This was a great insult to the superior talent of Matilda Smith, who was a brilliant artist, as is evident in her glorious illustrations.

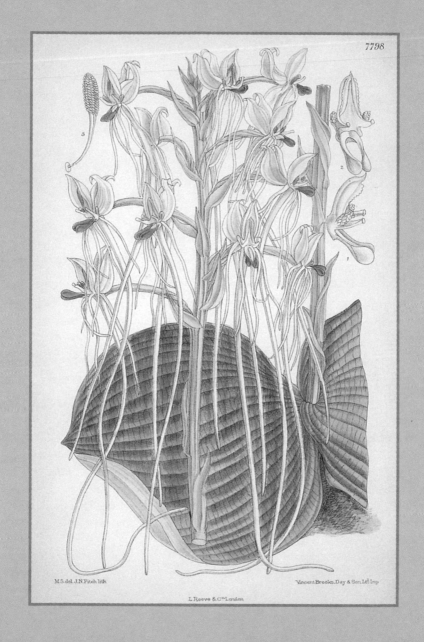

M.S. del. J.N.Fitch lith.

Vincent Brooks, Day & Son, Ltá Imp.

L.Reeve & Cᵒ.London.

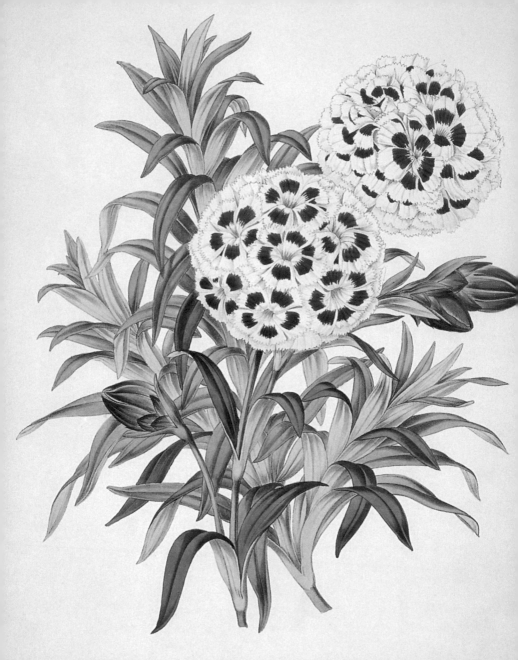

DIANTHUS VERSCHAFFELTII.

CHARLOTTE CAROLINE SOWERBY
(1820–1865)

*T*he Sowerbys and their extended family constituted a virtual tribe of talented artists and naturalists. Charlotte was the eldest daughter of George Brettingham, a conchological artist, and she was a descendant of the well-respected artist James Sowerby. Another relative, George Edward Sowerby, produced the botanical periodical, *Repository Magazine.* All of the Sowerby men are recognized for their talents and contributions to their particular fields of endeavor, but little mention or credit is given to the gifted women of this prestigious family.

Charlotte Sowerby, a fine botanical artist, contributed plates to Henderson's *Illustrated Bouquet* and to other works. Ellen Sowerby was also an artist of enormous talent. However, while the 1994 edition of *The Art of Botanical Illustration* contains a detailed account of the Sowerby men, no mention is made of either Charlotte or Ellen.

Almost nothing is known of Charlotte's life. In *British Gardens,* published in 1980, Charlotte Caroline Sowerby is hailed as one of the three most important members of the Sowerby family, but no further information about her is included.

As with many Victorian women artists, Charlotte Sowerby's art must speak for itself as all that will ever be known about the woman herself.

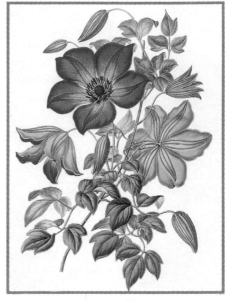

ABOVE: THIS GORGEOUS ILLUSTRATION OF CLEMATIS BY CHARLOTTE CAROLINE SOWERBY APPEARED IN THE *ILLUSTRATED BOUQUET.* SOWERBY WAS FROM A FAMOUS FAMILY OF NATURALISTS AND BOTANISTS, AND WHILE THE MEN IN THE FAMILY ACHIEVED GREAT RECOGNITION, THE SOWERBY WOMEN—EQUALLY TALENTED AND PROLIFIC—WERE RARELY CITED. OPPOSITE: CHARLOTTE CAROLINE SOWERBY DREW THIS LOVELY *DIANTHUS* FOR HENDERSON'S *ILLUSTRATED BOUQUET.*

MISS JANE TAYLOR
(Flourished 1870s)

ane Taylor of Rye, Sussex, was a fine illustrator and quite adept at portraying orchids and other exotic plants. She contributed numerous drawings for Maund's *The Botanist*. Her work ranks with that of the top female artists of her day, and she shared the pages of *The Botanist* with Mrs. Bury, the Misses Maund, and Mrs. Augusta Withers.

There is almost no information about the life of Miss Jane Taylor other than the fact that she painted still lifes and contributed flower drawings to the Society of British Artists in London.

LEFT: A RARE ORCHID
(*ACANTHEPHIPPIUM*) AS
DRAWN BY JANE TAYLOR.
OVERLEAF: JANE TAYLOR'S *GALE-ANDRA DEVONIANA* (LEFT) AND
AN *ONCIDIUM* ORCHID (RIGHT).

JANE TAYLOR DID A GREAT
MANY DRAWINGS FOR MAUND'S
BOTANIST, INCLUDING THIS
HANDSOME RENDITION OF A
COMPARETTIA ORCHID.

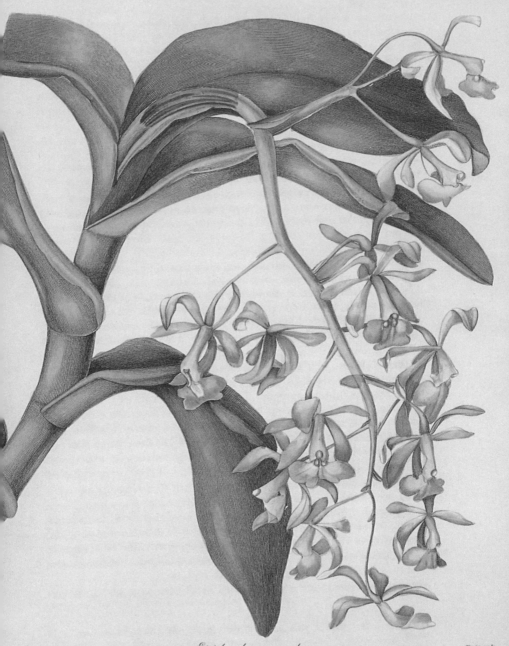

Epidendrum nutans.

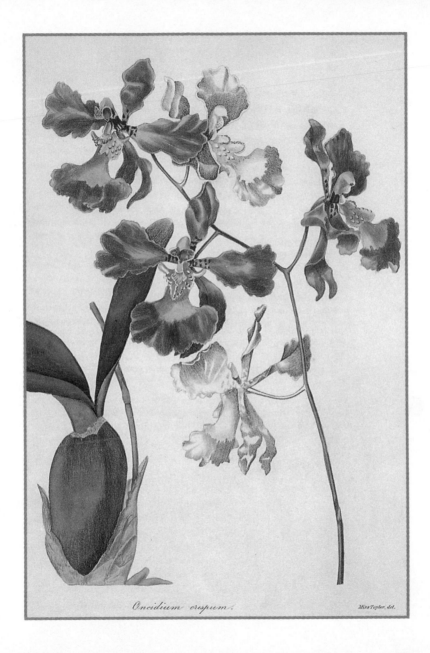

Oncidium crispum.

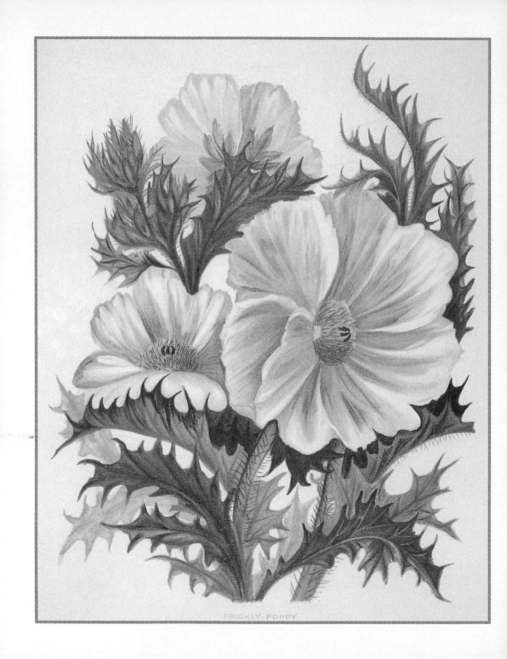

PRICKLY-POPPY

EMMA HOMAN THAYER
(1842–1908)

*E*mma Homan Thayer, the daughter of George Wand and Emma Homan, was born in New York in 1842. Educated at Rutgers College in New Jersey, she studied her craft at the National Academy of Design. One of the original members of the Art League of New York, she originally worked in figure painting and was exhibited at the National Academy. In 1883, she married George A. Graves, who died four years later, in 1887. Later, she married Elmer A. Thayer.

In 1882, Emma moved to Colorado, where she was greatly impressed with the splendor of the region, and she started painting wildflowers. Her first book, *Wild Flowers of Colorado* was published in 1885. Her next book, *Wild Flowers of the Pacific Coast,* was published in 1887. "To those who are familiar with the flowers of California, may they welcome these in my collection as old friends," she wrote in the introduction to the book, "and to those who are strangers, may they prove an introduction to the home of the beautiful wild

> IN THE PLACES MOST DIFFICULT TO ACCESS I FOUND THE MOST BEAUTIFUL FLOWERS. IT WOULD SEEM AS IF THEY WISHED TO HIDE THE DELICATE MEMBERS OF THEIR FAMILY FROM THE RUDE GAZE OF THE WORLD, SHELTERED IN SOME NOOK OF THE ROCKS, LIKE A MINIATURE CONSERVATORY TENDERLY CARED FOR BY THE FAIRIES OF THE MOUNTAINS.
>
> OFTEN YOU WILL SEE A MOST BEAUTIFUL SPECIMEN GROWING JUST BEYOND YOUR REACH ON SOME RUGGED POINT. THE DESIRE TO POSSESS IT IS SO GREAT YOU CAN HARDLY RESIST THE DANGEROUS REACH. I ONCE SAW A WHOLE BED OF FINE BELL-SHAPED FLOWERS ON A POINT ABOVE ME, IMPOSSIBLE TO CLIMB. I HAD SPENT DAYS IN TRYING TO FIND THIS VARIETY, AND HERE THEY WERE A FEW FEET ABOVE MY HEAD, BUT NO HUMAN HAND COULD TOUCH THEM. THEY GREW WONDROUSLY BEAUTIFUL WHILE I GAZED, AND I IMAGINED THEY GREW LARGER AND LARGER UNTIL THEY LOOKED LIKE A WHOLE CHIME OF BELLS RINGING OUT A DIRGE TO MY DISAPPOINTED AMBITIONS.
>
> —EMMA HOMAN THAYER,
> *WILD FLOWERS OF THE PACIFIC COAST*, 1887

ABOVE: A MORNING GLORY OPPOSITE: A PRICKLY POPPY FROM ONE OF EMMA HOMAN THAYER'S WILDFLOWER BOOKS. THOUGH LITTLE KNOWN, THAYER IS CLEARLY A KNOWLEDGEABLE ARTIST.

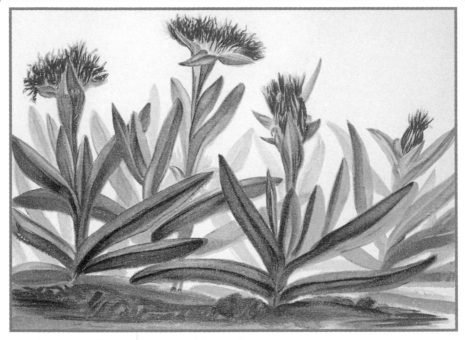

ABOVE: EMMA HOMAN THAYER TRAVELLED THROUGHOUT THE NORTHWEST TO RENDER HER DRAWINGS DIRECTLY FROM NATURE.

OPPOSITE: EMMA HOMAN THAYER PUBLISHED THIS SPLENDID CACTUS IN HER WORK *WILD FLOWERS OF COLORADO*.

flowers of the Pacific Coast."

Mrs. Thayer was a seasoned traveler and adventurer, and her books were written in diary style. Her vivid descriptions of railroad trips on the Pacific Coast and journeys through Colorado and the Rocky Mountains demonstrated her vitality and a devotion to the land which she obviously felt with great passion. A wildflower enthusiast, she drew mainly from live plants, often endangering her own life to capture the ideal specimen for study. She was known as a gentle but determined soul, always available to assist the needy, particularly the Native Americans she encountered on her travels.

Emma Homan Thayer published many other books during her lifetime. She died in Denver in 1908 at the age of sixty-six.

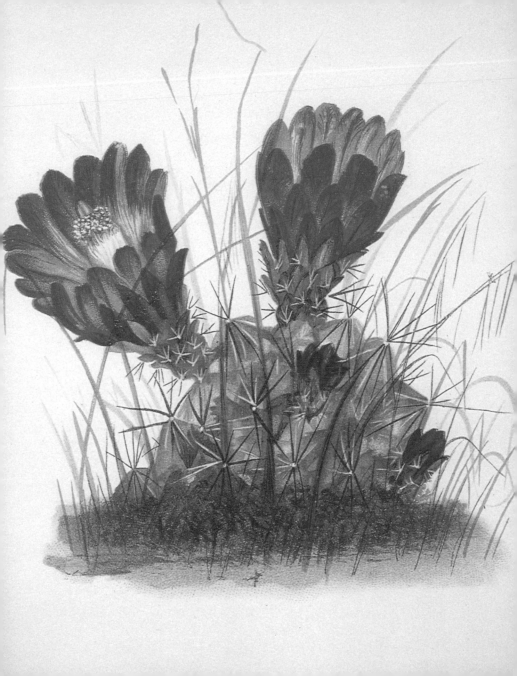

LOUISA ANNE MEREDITH TWAMLEY
(1812—1895)

orn in Birmingham, England, Louisa Anne Meredith Twamley was a prodigious writer and an excellent illustrator of plants. Her first books were published under her maiden name, Louisa Anne Meredith, and this has caused some confusion among scholars in properly crediting this proficient author and artist.

Also a poet, Louisa Anne published her first book, *Poems*, in 1835. It contained various verses that she illustrated with her own fine etchings of flowers and with drawings of Tintern Abbey and Kenilworth. In her second and more financially successful book, *Romance of Nature, or The Flower Season Illustrated*, she dedicated the volume to Wordsworth and wrote: "I love flowers as forming one of the sweetest links in the God-written poetry of Nature." Two more volumes were published in 1839, *Flora's Gems* and *Our Wild Flowers*. The latter, a book for children, addressed the author's difficulties remembering the Latin names of flowers ("hard names" as she called them). *Our Wild Flowers* attempted to educate children in the naming of flowers and even more importantly in their inherent beauty. "I have wreathed England's wildflowers for England's children!" she ecstatically exclaimed in the preface to the work.

In the late 1830s Louisa Anne emigrated to Australia, for in addition to her passion for flowers, she had a great love of travel and adventure. In 1839 she published *An Autumn Ram-*

ABOVE: THIS ILLUSTRATION INCLUDES THE ARTIST'S INITIALS, FASHIONED IN TWIGS. L.A.M., LOUISA ANNE MEREDITH, WAS TWAMLEY'S MAIDEN NAME. OPPOSITE: AN ILLUSTRATION OF SUMMER CLEMATIS FROM *SOME OF MY BUSH FRIENDS OF TASMANIA.*

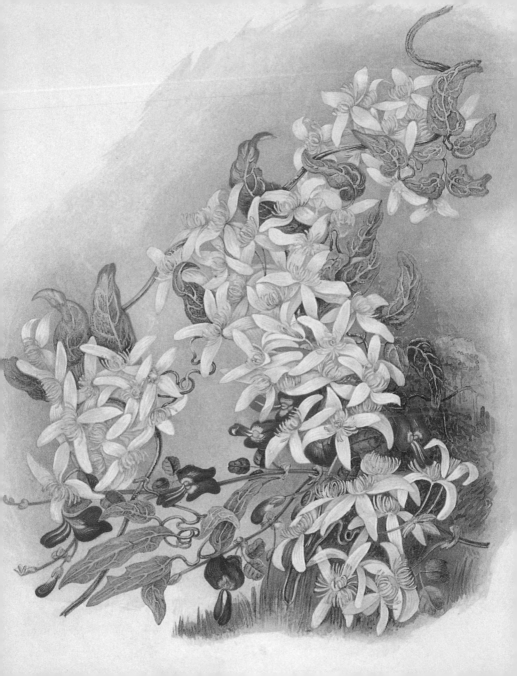

ble on the Rye. Though she was describing a difficult and terribly uncomfortable journey through the Blue Mountains, she still wrote that for "persons of refined taste and retentive memory, few enjoyments are greater or more permanent than the sight of grand and beautiful scenery. While present it gives a feeling of rapturous delight, almost inspiration." In the same year, when she was in her mid-twenties, she married her cousin, a squatter from Australia, and together they moved to New South Wales, where she kept a journal of her experiences. She later recalled her insights in *Notes of Sketches of New South Wales.*

OPPOSITE: IN *OUR WILD FLOWERS*, LOUISA ANNE TWAMLEY COMBINES BUTTERFLIES WITH *PROTEA* AND NATIVE *ARBUTUS* TO CREATE THIS HANDSOME ILLUSTRATION.

In 1840, Twamley settled in Tasmania, continuing her ever-increasing interest in the study of the region's flora and fauna. Although she never became—or even aspired to become —a professional illustrator or serious botanist, she was able to blend nature and her sentimental thoughts successfully in charming and artistic floral drawings.

Clearly, Louisa Anne Twamley fell wildly in love with Tasmania, and this enthusiasm resulted in *Some of My Bush*

ABOVE: THE FRONTISPIECE TO *SOME OF MY BUSH FRIENDS IN TASMANIA*.
OPPOSITE: A DRAWING FROM TWAMLEY'S *OUR WILD FLOWERS*.

Friends in Tasmania (meaning, literally, her plant friends), published in 1860. Dedicating the book to Her Majesty the Queen, Twamley drew the flowers, berries, and insects of the area, including detailed plant descriptions with her poetry and

ABOVE: FROM *OUR WILD
FLOWERS*. OPPOSITE: A VARIETY
OF INSECTS, ALONG WITH WHITE
LILY, FUSCHIA, RIVER ROSES, AND
OTHER FLOWERS IS INCLUDED IN
THIS EXAMPLE OF TWAMLEY'S
UNIQUE ILLUSTRATIVE STYLE.
OVERLEAF: TWAMLEY'S DRAWING
OF A WREATH FOR *SOME OF MY
BUSH FRIENDS IN TASMANIA*
(LEFT) AND *FRITILLARIA* FROM
OUR WILD FLOWERS.

essays. Another tribute to the country was recalled in a later publication, *My Home Is Tasmania.*

Amateur painting was fashionable in Tasmania during the 1840s, and Louisa Anne Twamley was not alone among the artists who traveled there for inspiration. The climate and soil of the country took very well to English gardening practices and thus lured many painters and nature lovers to this remote and exotic land. (Though whether Mrs. Twamley's husband shared her interest in flowers, her appreciation of nature, or her love of travel was never recorded.)

Through her many books and illustrations, Louisa Anne Twamley greatly influenced the many women (and perhaps some men) of her day who bought her books. Like many Victorian women, she received little credit or recognition for her achievements, though she never relinquished her positive attitude or the romantic fantasies that fueled her work.

Louisa Anne Twamley remains one of the most original—and certainly one of the more adventurous—Victorian women of flowers.

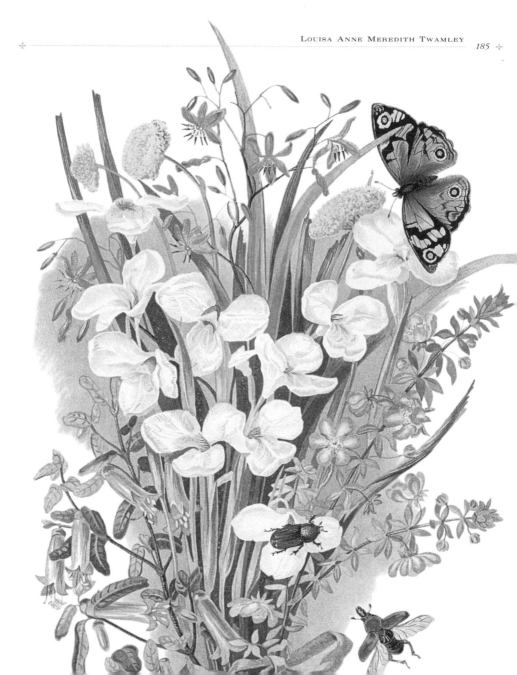

YE ARE THE STARS OF EARTH,— AND DEAR TO ME
IS EACH SMALL TWINKLING GEM THAT WANDERS FREE
'MID GLADE OR WOODLAND, OR BY MURM'RING STREAM,
FOR YE TO ME ARE MORE THAN SWEET OR FAIR,
I LOVE YE FOR THE MEM'RIES THAT YE BEAR
OF BY-GONE HOURS WHOSE BLISS WAS BUT A DREAM.
—L. A. TWAMLEY, "EARTH STARS"

ELIZABETH TWINING
(1805–1889)

*E*lizabeth Twining spent most of her life in thrall to flowers. Born into the famous tea dynasty that still carries the family name, she was blessed with the financial wherewithal to pursue her deep love and appreciation of botany, along with a lifelong propensity for helping the poor.

Twining was raised on Norfolk Street, the Strand, London, and along with her sister, Louisa, received training in art and drawing from a very young age. As a child, Elizabeth liked to work on doll houses and their contents, and she drew miniatures copied from art found in galleries around London. This practice instilled in Elizabeth a talent for minute detail. In 1827, while traveling in Brussels with her father and two sisters, Elizabeth sketched various parts of the city in great detail. She soon excelled in botanical art.

Much of Elizabeth's life was recounted by her sister Louisa, who published two books in 1893, *Recollections of Life* and *Some Facts in the History of the Twining Family*. Louisa wrote that Elizabeth studied *Curtis's Botanical Magazine*, which contained drawings of new and exotic plants, and copied the pictures, drawing everything from orchids to hippeastrums. Louisa also described Elizabeth's many visits to the gardens of the Royal Horticultural Society at Chiswick in the mid-1830s. This veritable wonderland of flowers and plants was an obvious source of inspiration for the young artist.

> FROM THE EARLIEST YEARS OF CHILDHOOD, WHEN THE SIMPLE AND ABUNDANT DAISY YIELDS ONE OF THE MOST VALUED RECREATIONS, UNTIL THE CLOSE OF LIFE, WHEN FLOWERS ARE PLANTED ON THE GRAVE, THERE IS NO PERIOD WHEN SOME OF THE COUNTLESS VARIETY OF PLANTS DO NOT MINISTER IN SOME WAY TO OUR COMFORT AND ENJOYMENT.
> —ELIZABETH TWINING
> *ILLUSTRATIONS OF THE NATURAL ORDER OF PLANTS WITH GROUPS AND DESCRIPTIONS*, 1868

OPPOSITE: A PRETTY MELANGE OF ROSES BY ELIZABETH TWINING.

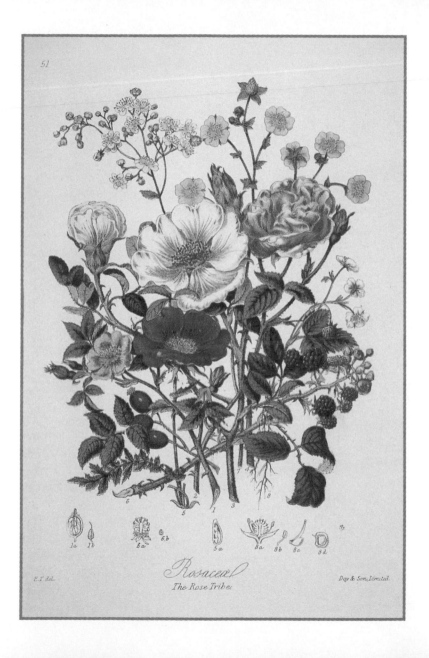

Rosaceæ

The Rose Tribe.

E.T. del.

Day & Son, Limited.

By 1849, Elizabeth Twining had published two volumes of her landmark *Illustrations of the Natural Order of Plants,* which confirmed her talent for rendering flowers. These drawings were based on plants displayed at the Royal Botanical Gardens in Kew and at Lexden Park, Colchester. And their accuracy is confirmed by the fact that these original drawings are housed in the British Museum, in the Natural History section of the Botany Department.

ABOVE LEFT: A BOTANICAL DRAWING FROM *ILLUSTRATION OF THE NATURAL ORDER OF PLANTS* BY ELIZABETH TWINING. ABOVE RIGHT: A TRIBE OF PASSION FLOWERS NESTING AMONG OTHER FLOWERS BY ELIZABETH TWINING. OPPOSITE: *MELASTOMA* BY ELIZABETH TWINING.

Like many Englishwomen who wrote about plants and flowers, Twining was fiercely proud of her country and the natural wonders of England. In the 1868 edition of *Natural Order,* she declared, "Among those tribes of which we have the finest specimens in the British Isles may be noticed the oak, elm, ash and willow-trees: these all attain a vigorous growth in the temperate climate of this country. The oaks of England are not surpassed in any other part of the world. The

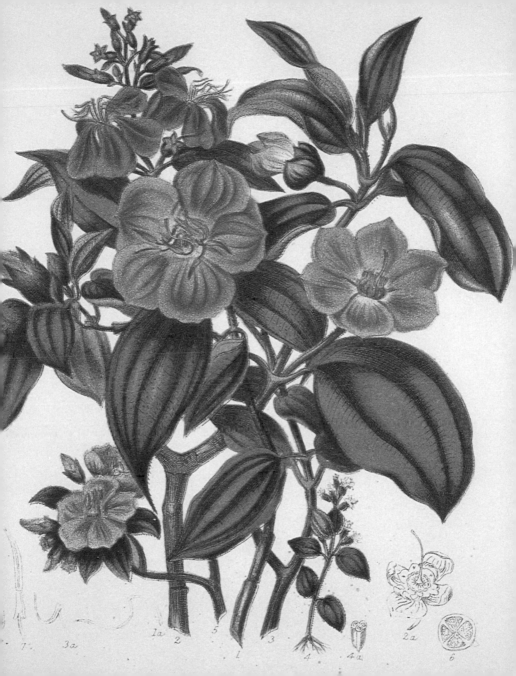

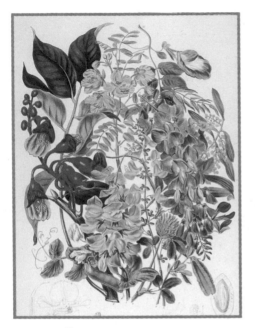

ABOVE: Elizabeth Twining had a fine hand at illustrating bouquets.
RIGHT: From Twining's *Illustrations of the Natural Order of Plants*.
OPPOSITE: Twining's rendition of an array of cacti is a beautiful piece of art but not botanically accurate.

ash of the Isle of Wight rivals that of North America." Illustrations of Twining's *The Natural Order of Plants* can be found in the British Museum (Natural History).

Yet Twining's life was not solely devoted to botany. She also spent a great deal of time helping the destitute. In 1856, she moved into her family home in Twickenham and had the local alms house refurbished. She bought land in 1880 and established the Twining Hospital, which provided medical care for the poor. (The institution was later renamed St. James Hospital.) Twining also organized "mother's meetings" in London and founded the Bedford Home for Girls. She wrote fourteen books of religious essays including *Ten Years in a Ragged School* (1857) and *Readings for Mother's Meetings*. Her accomplishments were many, and she lived a life that combined the best of many worlds. Elizabeth Twining was a Victorian lady who never stopped caring for those less fortunate than herself. She was also an accomplished artist who brought a classic sense of proportion and detail, as well as a profound knowledge of botany, to her fine illustrations.

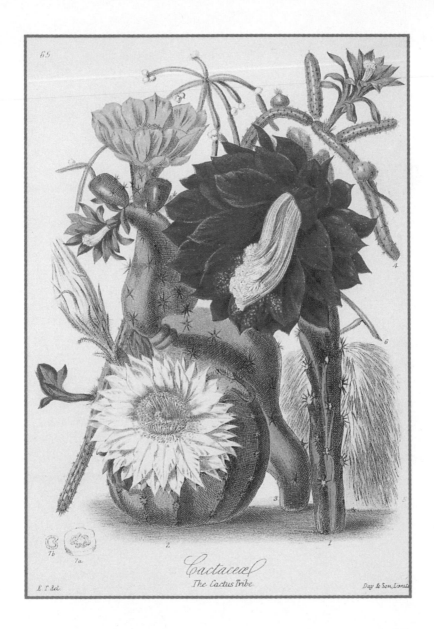

65

Cactaceæ

The Cactus Tribe

E. P. del.

Day & Son, Limited

PRISCILLA WAKEFIELD
(1751—1832)

*P*riscilla Wakefield was born at Tottingham on January 31, 1751. At the age of twenty, she married Edward Wakefield (1750-1826), a merchant of Lad Lane (now Gresham Street) in London. Although she was a known philanthropist and a promoter of savings banks, she established her reputation as a writer for both children and adults. Her first book, *Juvenile Anecdotes Founded on Facts*, appeared in two volumes (1795, 1798) and was quite successful, published through eight editions. Wakefield eventually switched from storytelling to science and travel writing. Her second book, *The Juvenile Travellers* (1801) —a fictional tour through Europe—was even more successful than her first, culminating in nineteen editions.

While primarily known as a writer of children's books, Priscilla Wakefield's contribution to horticulture was equally impressive. Her book, *An Introduction to Botany in a Series of Familiar Letters*, published in London, 1796,

was outrageously popular. Designed to introduce botany to a younger audience, the book sold thousands of copies and was even published in French. Based on the success of *An Introduction to Botany*, she published *An Introduction to the Classification of Insects on a Series of Letters* in 1816.

A woman of varied interests, Wakefield also wrote a book about animals. *Instinct Displayed in a Collection of Well-*

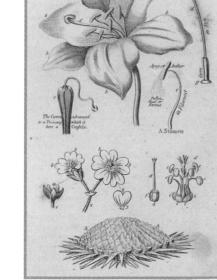

Authenticated Facts, Exemplifying The Extraordinary Sagacity of Various Species of the Animal Creation (published in 1821, London) is a compilation of letters to her granddaughter, Emily. Full of poems as well as comments on nature, this interesting little book

LEFT AND BELOW: IN HER BOOK, PRISCILLA WAKEFIELD PRESENTED A DOZEN PLATES SHOWING SPECIFIC FLOWER PARTS AND THE SHAPES OF LEAVES. THE BOOK WAS PRINTED IN BLACK AND WHITE.

details all types of insects and animals.

Wakefield published more than twenty-four volumes during her long and prolific career as a writer. Some of her other titles include: *Leisure Hours and Entertaining Dialogues; Mental Improvements, or the Beauties and Wonders of Nature and Art; Reflections on the Present Condition of the Female Sex with Suggestions for its Improvement; A Family Tour Through the British Empire;* and *A Brief Life of William Penn,* among others.

LADY CAROLINE CATHERINE WILKINSON
(1822—1881)

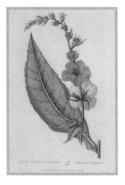

*C*aroline Catherine Lucas was born on May 10th, 1822, the daughter of Henry Lucas, Esq. of Uplands Glamorganshire. In October of 1856, at the age of thirty-four, she married the well-known Egyptologist Sir Gardner Wilkinson. He was fifty-nine at the time of their marriage.

Lady Wilkinson helped edit her husband's work, *Desert Plants of Egypt*, which included drawings made by her husband from 1823 to 1830. According to the *Journal of Botany*, 1880, "The plants which Sir Gardner Wilkinson collected during his explorations of the Egyptian deserts were presented by him to the British Museum and are now in the Herbarium of the Institution."

Lady Wilkinson is probably best known for her drawings of fungi, although her *Weeds and Wildflowers: Their Uses, Legends and Literature*, published in 1858, was a very successful and informative book. In it she quotes Tennyson, Wordsworth, and Keats on the beauty of nature. The twelve engravings in the book were done by another woman, and credited by Lady Wilkinson in a footnote. "I am indebted to Mrs. Berrington of Woodland Castle for the coloured illustrations," Wilkinson wrote.

The illustrations in *Weeds and Wildflowers* are botanically correct, and the style of the book helped establish a precedent in the annals of botanical volumes. Even though very little is known about Lady Wilkinson, *Weeds and Wildflowers* represents an important contribution to botany and a further advancement of the work of women in the field.

> IN EVERY PLANT
> THERE LIVES A SPIRIT, MORE OR LESS AKIN
> UNTO THE SPIRIT OF HUMANITY.
> SOME HEAL DISEASES DIRE; OTHERS WAKE
> STRANGE WHIMSIES IN THE BUSY BRAIN OF MAN.
> —FROM THE GERMAN OF LUDWIG TIECK, AS
> QUOTED IN THE PREFACE TO *WEEDS AND WILDFLOWERS: THEIR USES, LEGENDS AND LITERATURE* BY LADY WILKINSON, 1858

ABOVE: THE COMMON MULLEIN IS QUITE A HANDSOME FLOWER. OPPOSITE: A DELICATE AND ACCURATE RENDERING OF A WOOD SORREL. OVERLEAF: A DELICATE BOUQUET OF BINDWEED. EACH OF THESE PLATES WAS PUBLISHED IN LADY WILKINSON'S *WEEDS AND WILDFLOWERS*.

SEA BIND-WEED
AND SMALL BIND-WEED.

Convolvulus (calystegia) Soldanella.
and Convolvulus arvensis.

Mrs. E. W. Wirt
(1784—1857)

*M*rs. E. W. Wirt was born Elizabeth Washington Gamble in Richmond, Virginia. A lady of polite society, she married William Wirt at the age of seventeen. Wirt was obviously a devoted husband: in 1817 he almost forfeited an attorney generalship in Washington, fearing Mrs. Wirt would not adjust to life away from family and friends in Virginia. Equally devoted to her husband, however, Mrs. Wirt accompanied him to Washington and then to Baltimore where they eventually settled.

> THE LADY WHO HAS GIVEN HER LEISURE HOURS TO THIS LITTLE PLAY OF FANCY, HAS NOT THE VANITY TO ATTACH ANY SERIOUS CONSEQUENCE TO IT. THE BAGATELLE, SHE TRUSTS, IS TOO LIGHT TO ATTRACT THE GRAVE CENSURE OF THE CRITIC BY PROFESSION. IT HAS BEEN AN INNOCENT RECREATION TO HERSELF; AND IT WITH NO HIGHER EXPECTATION THAN OF AFFORDING THE LIKE AMUSEMENT TO OTHERS, THAT IT IS NOW GIVEN TO THE PRESS.
>
> —MRS. E. W. WIRT, *FLORA'S DICTIONARY*

Happily married, the Wirts governed a large household of twelve children. Well versed in polite accomplishments, the family engaged in a variety of activities from reading and writing to music and art. For the sheer entertainment of her family and friends, Mrs. Wirt compiled and illustrated *Flora's Dictionary*. Her earnest endeavor was greeted with wide-spread enthusiasm among her friends, who demanded copies of the beautifully illustrated dictionary. Mrs. Wirt made numerous copies by hand, each one a labor of love. Subsequently, one of these copies ended up in Boston, where it captured the attention of at least one publisher. In 1829 a more fully

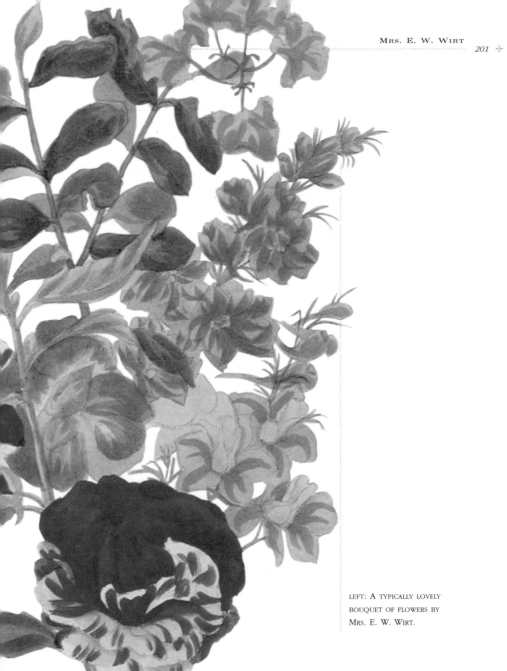

LEFT: A TYPICALLY LOVELY
BOUQUET OF FLOWERS BY
Mrs. E. W. Wirt.

developed version was published by Fielding Lucas in Balti-
more. A botanical favorite, *Flora's Dictionary* went through
many editions. The combination of botanical information pro-
vided by Mrs. Wirt, as well as her hand-picked selections of
poetry and historical information, won her the admiration of
many.

The book itself is
exquisitely printed with an
elaborate cover and full-
color pages. In her pref-
ace, Mrs. Wirt introduces
her readers to the wonder-
ful world of flowers, con-
veying her knowledge of
plants and providing a
brief sketch on the life of
Linnaeus in simple yet
informative prose. The
book is also illustrated
with drawings by Wirt.
Today *Flora's Dictionary* is
a collector's item, perhaps
among the most prized
language-of-flowers books
issued in the nineteenth
century.

LEFT: MRS. E. W. WIRT'S
FLORA'S DICTIONARY, PUBLISHED
IN 1855, WAS A FINE EXAMPLE
OF A LANGUAGE-OF-FLOWERS
BOOK AND INCLUDED SUCH FINE
ILLUSTRATIONS AS THIS PASSION-
FLOWER. BELOW: FUSCHIA BY
MRS. E. W. WIRT.

MRS. AUGUSTA INNES BAKER WITHERS
(1792—1869)

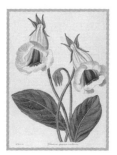

ABOVE: *GLOXINIA SPECIOSA* BY MRS. AUGUSTA INNES WITHERS. RIGHT: A GROUPING OF DAHLIAS, AS SEEN IN *THE ILLUSTRATED BOUQUET*, SHOWCASES MRS. WITHERS'S REMARKABLE TALENT AND VIVID USE OF COLOR. OPPOSITE: *LILIUM THUNBERGIANUM* BY MRS. WITHERS.

*A*ugusta Innes Baker, the daughter of a minister, was thirty-three years old when she married the accountant Theodore Gibson Withers in 1825. He was almost twenty years her senior. They moved to Grove Terrace, where they lived comfortably for many years among the affluent and artistic crowd from that area of London. Augusta became friendly with many rich and prominent people who encouraged her artistic aspirations. Soon she was not only creating art, she was teaching it as well. Her reputation earned her the position of Flower Painter in Ordinary to Queen Adelaide.

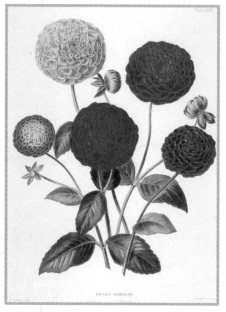

DWARF DAHLIAS.

During the 1830s and 1840s, Withers produced drawings for various books and magazines. She illustrated the entire *Pomological Magazine* from 1828 to 1830, and she brought exceptional accuracy and beauty to more than 100 of the plates in Maund's famous *The Botanist* (1836-1842). She also worked as an illustrator for *Curtis's Botanical Magazine*. At one point, she boldly applied

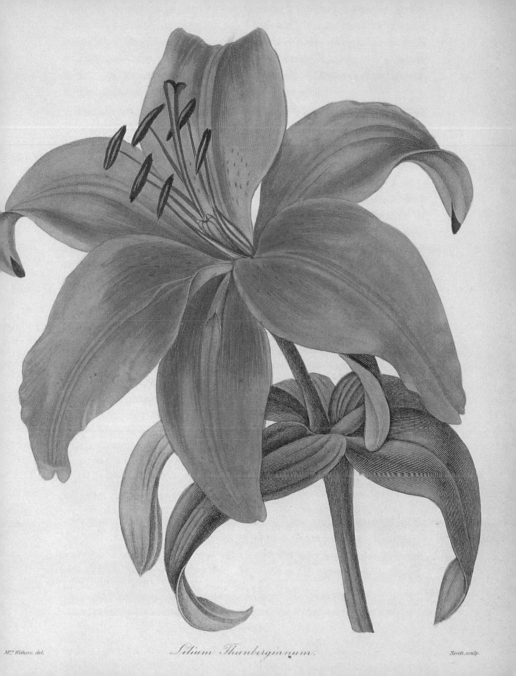

Lilium Thunbergianum.

to Sir Joseph Dalton Hooker at the Royal Botanical Garden at Kew for the appointment of Botanical Flower Painter. Hooker rejected her, allegedly because she was a woman and no woman had ever held such an esteemed position. Withers persevered despite such prejudice. She contributed excellent work to *The Floral Cabinet, Thompson's Gardener's Assistant* and the *Transactions of the Horticultural Society.* Equally at ease drawing fruits, poultry, and game, she produced illustrations for the 1828 edition of *Flowers and Fruits from Nature.* In 1831, John Loudon praised Withers in his *Gardener's Magazine.* "It is due to Mrs. Withers of Grove Terrace, Lisson Grove," Loudon wrote, "to state that her talents for teaching

[botanical illustration] are of the highest order, as many of the plates in the *Transactions of the Horticultural Society* and the *Pomological Magazine* abundantly show." This was praise indeed, especially for a woman.

In 1834, Withers exhibited her paintings at the Horticultural Society and was highly complimented. Perhaps her crowning achievement, though, were the remarkable plates she, along with Miss Drake, rendered for James Bateman's *Orchidaceae of Mexico and Guatemala* (1837 1841). This monumental work, weighing thirty-eight pounds, stunned the horticultural world. The critic Blunt described it as "probably the finest and certainly the largest botanical book ever produced with lithographic plates." The orchid plates created for this volume are among the most exceptional ever drawn, capturing the true character of these exquisite flowers. Yet the contributions to the Bateman book by Mrs. Withers and Miss Drake went virtually unno

ABOVE: THIS EXQUISITE *BRUGMANSIA* BY MRS. AUGUSTA WITHERS APPEARS IN MAUND'S *THE BOTANIST*.

OPPOSITE: MRS. AUGUSTA WITHERS WAS PARTICULARLY ADEPT AT DRAWING ORCHIDS, AS IS EVIDENT IN THIS RENDITION OF A *CATTLEYA INTERMEDIA*.

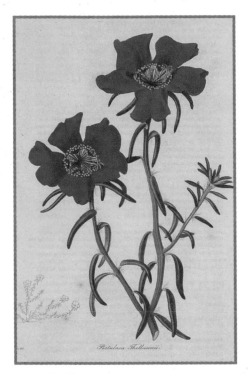

ABOVE: MRS. WITHERS WAS AN
ARTIST WHO WAS CAPABLE OF
ACCURATELY RENDERING MANY
DIFFERENT VARIETIES OF
FLOWERS, INCLUDING THIS
DETAILED PORTRAIT OF A
PORTULACA.
OPPOSITE: *PHARBITIS LEARU*
OVERLEAF: *TRICHOPILIA TORTILIS*
(LEFT) AND *CLEMATIS AZUREA*
(RIGHT).

ticed. Almost nothing was ever written about their participation in the creation of this landmark book.

In the late 1840s, the fortunes of the Witherses began a steep decline. Throughout their marriage, they had moved many times, from Grove Terrace to Marylebone to Pembroke Square to Parson Green and finally, in 1848, to Paultons Square in Chelsea. Each time, they had moved up in the world. But in 1849, Queen Adelaide, Augusta's patron, died, and the couple began experiencing financial difficulties. These problems were exacerbated in 1850, when Theodore Withers went blind.

Too proud to approach the Artist's Benevolent Fund, Augusta began selling her work to pawnshops. She appealed to Queen Victoria, who eventually bought one of Withers's cherished sketchbooks, but financial ruin was fast approaching.

The couple moved to smaller and smaller quarters. Mr. Withers died in 1869, and Augusta finally applied to the Privy Purse. She wrote a heartfelt letter describing her dire circumstances to the secretary, but her appeal was never answered. Penniless and destitute, Augusta Withers died of pneumonia in 1877, at the age of eighty-five.

A little more than a century later, in 1985, a single volume of drawings by Augusta Withers was auctioned at Sotheby's for almost $30,000.

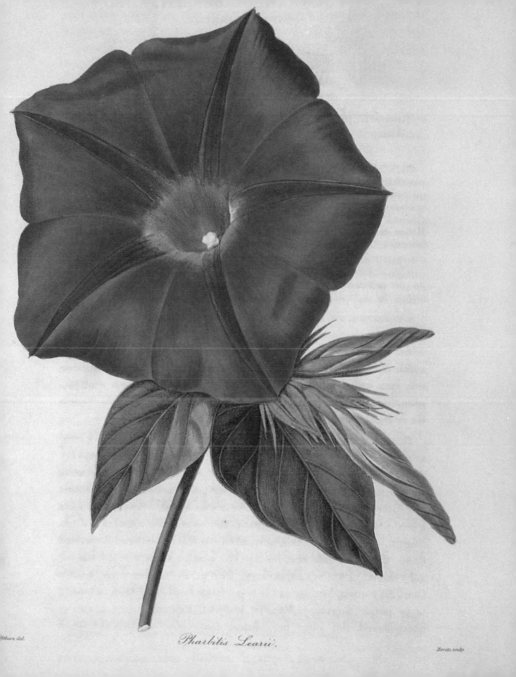

Pharbitis Learii.

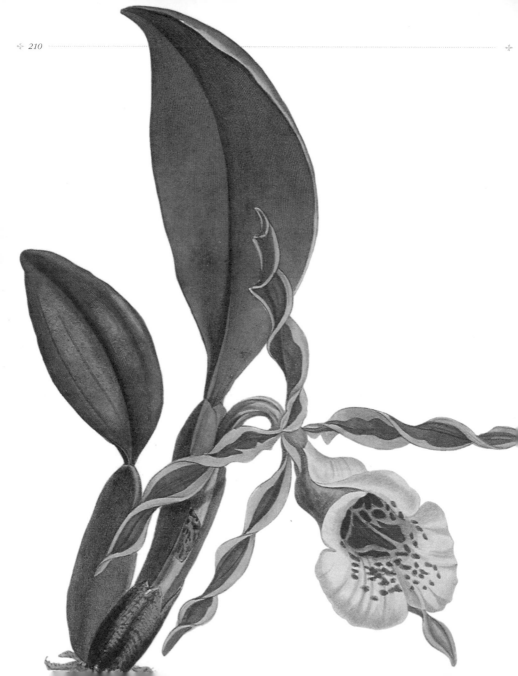

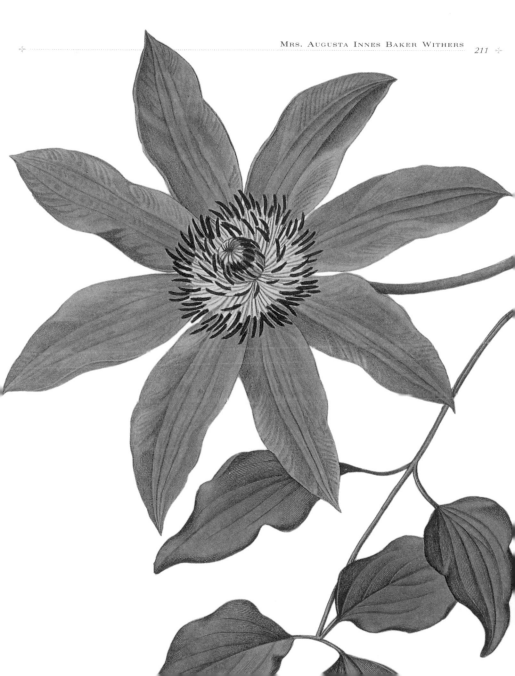

ABOVE: FIVE VARIETIES OF
EPACRIS. OPPOSITE: KNOWN
IN THE NINETEENTH CENTURY
AS A LUCULIA, THIS FANCIFUL
BOUQUET APPEARED IN THE
BOTANIST.

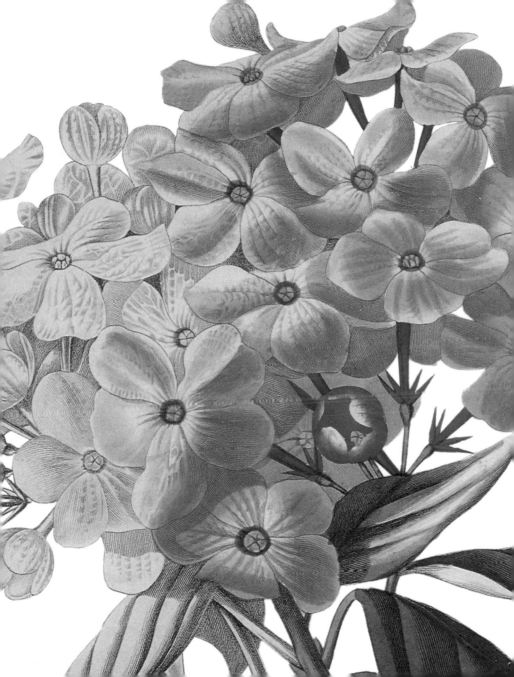

ACKNOWLEDGMENTS

This book originated in 1965, when I started collecting botanical illustration books. What began as a quest for invaluable reference material for horticultural research turned into a love affair with exquisite botanical art. It is difficult to thank everyone who helped over such an extended period of time, so please forgive me for any undue omissions.

My first gratitude is to Elisabeth Woodburn Books of Hopewell, New Jersey, and its managers, Brad Lyon and Joanne Fucello, who helped to nurture my initial interest in eighteenth and nineteenth century botanical art volumes and have kept my collection blooming over the years. Additional thanks go to Jim Hink of Anchor and Dolphin Books in Newport, Rhode Island, for his vast knowledge of botanical art.

Special thanks to the many librarians from libraries and museums throughout the United States and England whose invaluable assistance have made this book possible.

My thanks extend to the following libraries, museums, and arboretums:

Hunt Institute for Botanical Documentation, Carnegie-Mellon University, Pittsburgh, PA
Stroetzer Library, Florida State University, Tallahassee, FL
Florida State University, Tallahassee, FL
Academy of Natural Sciences, Philadelphia, PA
Pierpont Morgan Library, New York, NY
Naples Public Library, Main Branch, Naples, FL
The New York Botanical Garden, New York, NY
The Academy of Natural Science, Philadelphia, PA
The Metropolitan Museum of Art, New York, NY
The Natural History Museum, London, England
The Massachusetts Horticultural Society, Boston, MA
The Academy of Science, San Francisco, CA
The University of Florida, Gainsville, FL
The National Geographic Society, Washington, DC
Broughton Library, Harvard University, Cambridge, MA
Orleans House Gallery, Twickingham, London, England
Morton Arboretum, Lisle, IL
New-York Historical Society, New York, NY
New York Society of Illustrators, New York, NY
The New York Public Library, New York, NY
The Denver Public Library, Denver, CO
Philip Wilson Publishers, London, England
The Linnean Society, London, England
Free Library of Philadelphia, Philadelphia, PA
The British Museum, London, England
The Lindley Library, London, England

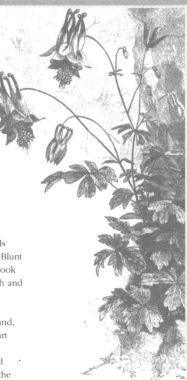

Royal Botanical Gardens, Kew, England
The Arnold Arboretum, Harvard University, Jamaica Plain, MA
The Fitzwilliam Museum, Cambridge, England
Royal Horticultural Society, London, England
Sotheby's, New York
In addition, many thanks to my fellow researchers:
Douglas Sellick, London, England
Janet Turner, Washington, DC
Barry Sussman, Chicago, IL
Roy Crafton, San Francisco, CA
Special thanks to Daniel Lloyd of Lloyds of Kew, Bookseller, London.

Great appreciation and thanks to Eric Strachan, who photographed most of the botanical illustrations for this book.

Also my thanks to fate who, in 1960, delivered into my hands the classic volume, *The Art of Botanical Illustration*, by Wilfred Blunt and William Stearn (London: Collins, 1950). It was Mr. Blunt's book that started my quest for knowledge and examples of eighteenth and nineteenth century botanical art and illustration.

My gratitude to Andrew Roy Addkinson, a former Head of Environmental Design at the College of Arts and Crafts in Oakland, California, who helped read the manuscript and advise me on art techniques and printing.

Last but most certainly not least, my sincere appreciation and thanks to Lena Tabori of Stewart, Tabori & Chang for grasping the full idea of this book. And overwhelming thanks to my dedicated and enthusiastic editor, Linda Sunshine, who is indeed a bright ray of light. Her hard work and encouragement have brought the women of flowers alive once again. Thanks also to her assistant, Alexandra Childs, for her editorial contribution.

BIBLIOGRAPHY

Anderson, Frank J. *An Illustrated Treasury of Cultivated Flowers,* New York: Abbeville Press, 1979.

Allen, R. C. *American Rose Manual,* Harrisburg: American Rose Society.

Arber, Agnes. *Herbals. Their Origin and Evolution. A Chapter in the History of Botany.* Cambridge: Stearns, 1912; reprinted in 1938, 1953, 1986.

Archer, Mildred. *Natural History Drawings in the India Office Library.* London: Published for the Commonwealth Relations Office, 1962.

Barber, Lynn. *The Heyday of Natural History.* New York: Doubleday, 1980.

Biddle, Moncure. *A Christmas Letter.* Philadelphia: Biddle & Co., 1945.

Blunt, Wilfred. *The Art of Botanical Illustration.* London: Collins, 1950. Reprint 1994, W.T. Stearn, Antique Collector's Club.

———. *Tulipomania.* Harmondsworth: Penguin Books, 1957.

Boyle, Frederick. *The Woodland's Orchids.* London and New York: Macmillan & Co., 1901.

Bridson, Gavin D. A., Donald E. Wendel, and James J. White. *Printmaking in the Service of Botany.* Pittsburgh: Hunt Institute for Botanical Documentation, 1986.

Brindle, J. V., and J. J. White. *Flora Portrayed: Classics of Botanical Art from the Hunt Institute Collection.* Pittsburgh 1985.

Buchanan, Handasyde. *Nature into Art.* London: Weidenfeld and Nicolson, 1979.

Butler, June. *Floralia.* Chapel Hill: University of North Carolina Press, 1938.

Captain Cook's Florilegium. London: Lion and Unicorn Press, 1973.

Catlow, Agnes. *Popular Field Botany,* 3rd ed., London: Reeve and Co., 1852.

Coates, Peter. *Flowers in History.* London: Weidenfeld and Nicolson, 1970.

Coats, Alice M. *Flowers and Their Histories.* London: Hutton, 1956.

———. *The Book of Flowers.* New York: McGraw-Hill, 1973.

———. *The Treasury of Flowers.* New York: McGraw-Hill, 1975.

Cooper, Susan Fenimore. *Rural Hours.* Philadelphia: Willis P. Hazard, 1854.

Curtis's Botanical Magazine. London: Blackwell Publishing for Bentham Moxon Trust, Kew, 1787 to present.

Daniels, Gilbert S. *Artists From the Royal Botanic Garden,* Pittsburgh: Kew, Hunt Institute Collection, 1985.

Deckert, H. *Maria Sybella Merien: Neues Blumenbach,* 2 vols.

Nurenberg: Leipzig, 1680.

Desmond, R. *A Celebration of Flowers: 200 Years of Curtis's Botanical Magazine.* London: Kew and Twickenham, 1987.

———. *Dictionary of Irish and British Botanists and Horticulturalists and Botanical Artists.* London: Taylor & Francis, 1994.

Desmond, R., & F. Nigel Hepper. *A Century of Kew Plantsmen,* London: The Kew Guild, 1993.

Dunthorne, Gordon. *Flower and Fruit Prints of the 18th and Early 19th Centuries.* Washington, D.C.: n.p. 1938.

Dupree, A. Hunter. *Asa Gray, 1810-1888.* Cambridge, MA: Harvard University Press, 1959.

Dykes, W. R. *Notes on the Tulip Species.* London: Herbert Jenkins, 1930.

Elliot, Brent. *The Treasures of the Royal Horticultural Society.* London: Herbert Press, 1994.

Fleming, Lawrence, and Alan Gore. *The English Garden.* London: Michael Joseph, 1979.

Gage, A. T., and W. T. Stearn. *A Bicentenary History of the Linnean Society of London.* London: Academic Press, 1988.

Grandville, J. J. *The Court of Flora.* New York: Braziller, 1981.

Grant, M. H. *Flower Painting Through Four Centuries,* London 1932.

Griegson, Mary. *An English Florilegium.* New York: Abbeville Press, 1988.

Hadfield, Miles, Robert Harling, and Leonie Highton. *British Gardeners: A Biographical Dictionary.* London: Zwimmer, 1980.

Hardouin-Fugier, E. and E. Grafe. *French Flower Painters of the 19th Century.* London, 1989.

———. *Pupils of Redouté.* London, 1979.

Henrey, Blanche. *British Botanical and Horticultural Literature Before 1800.* 3 vols. London: Oxford University Press, 1973.

Hepper, F. Nigel, ed., *Kew Gardens for Science and Pleasure,* Owing Mills: Stemmer House, 1982.

Hulme, Edward F. *Flower Painting in Water Colours.* London: Cassell Petter Galpin, n.d.

Hutton, Paul and Lawrence Smith. *Flowers in Art from East and West.* London: British Museum Publications, 1979.

Jackson, B. D. *Journal of the Royal Horticultural Society,* 49: 167-177.

James, Edward, ed. et al. *Notable American Women 1607-1950.* Cambridge: Harvard University Press, 1951.

Jardine, Sir William. *The Naturalist's Library,* vol. 11, by James

Duncan. London 1843.

Kaden, Vero. *The Illustration of Plants and Gardens 1500-1850*. London: Victoria and Albert Museum, n.d.

Kastner, Joseph. *A Species of Eternity*. New York: Knopf, 1977.

King, Ronald. *Botanical Illustration*. New York: Clarkson Potter, 1978.

LeMoyne de Morgues, Jacques. *Portraits of Plants*. London: Victoria and Albert Museum, 1984.

L'Heritier. *Sertum Anglicum* (facsimile). George Lawrence Edition. Pittsburgh: Hunt Institute for Botanical Documentation, 1963.

Lindberg, Jana Hauschild. *Orchids and Exotic Flowers*. New York: Dover, 1986.

Mabey, Richard. *The Frampton Flora*. Englewood Cliffs: Prentice-Hall, 1989.

———. *The Flowers of Kew*. New York: Atheneum, 1989.

Marshal, Alexander. *Mr. Marshal's Flower Album, from the Royal Library at Windsor Castle*. London: Gollancz, 1985.

Martyn, Mrs. S. T. *The Ladies Wreath*. New York: Martyn and Miller, 1851.

McIntosh, Charles. *The Flower Garden*. London: William Orr, 1838.

———. *The Greenhouse*. London: William Orr, 1840.

———. *The New and Improved Practical Gardener*. London: Thomas Kelly, 1860.

McMillan, N. F. *Mrs. Edward Bury*, Journal of Society Bibliography Natural History, vol. 5: 71-75.

McTigue, Bernard. *Nature Illustrated*. New York Public Library, New York: Abrams, 1989.

Metropolitan Museum of Art. *Metropolitan Flowers*. New York: Abrams, 1982.

Mille et un Livres Botaniques de la Collection Arpad Plesch. Bruxelles, Belgium: Arcade Publishing, 1973.

Miller, Thomas. *The Poetical Language of Flowers*. London: n p., n.d.

Morrison, Tony. *In Search of Flowers of the Amazon Forest*, Edited by Margaret Mee. London: Nonesuch Expeditions, 1988.

Muir, P. H. *Victorian Illustrated Books*. London: Batsford, 1971.

Nesbit, Ethel. *Flower Painting*. Glasgow: Blackie & Son, n.d.

Nissen, Claus. *Die Botanische Buchillustration*. Stuttgart: Anton Hiersemann, 1966.

Norwood, V. *Made from This Earth*. Chapel Hill: University North Carolina Press, 1993.

Osgood, Frances. *The Poetry of Flowers*. New York 1851.

Pratt, Anne. *Flowers and Their Associations*. London: Charles King and Co., 1840.

Pritzel, G. A. *Theasaurus Literaturae Botanicae*. Leipzig, 1872.

Redouté Treasury, A. London: Vendome Press, 1989.

Reinikka, M. *A History of the Orchid*. Coral Gables: University of Miami Press, 1972.

Rix, Martyn. *The Art of the Plant World*. Woodstock: Overlook Press, 1979.

Ross-Craig, Stella. *Drawings of British Plants*. London: Bell & Sons, 1950.

Scourse, Nicolette. *The Victorians and Their Flowers*. Portland: Timber Press, 1983.

Scrase, David. *Flowers of Three Centuries*, Washington 1983.

Sicherman, Barbara et al. *Notable American Women: A Biographical Dictionary*. Cambridge: Harvard University Press, 1980.

Sitwell, Sacheverell, and Wilfred Blunt. *Great Flower Books 1700-1900*. London: Collins, 1956. Reprinted: New York: H.F.G. Witherby Ltd. Atlantic Monthly Press, 1990.

Smith, Bernard. *European Visions and the South Pacific 1786-1850*. London: Oxford University Press, 1960.

Smith, G. and Sir Leslie Stephan and Sir Sidney Lee, eds. *The Dictionary of National Biographies*. London: Oxford University Press, 1917.

Sotheby's Magnificent Botanical Book. London: Sotheby's, 1987.

Stearn, William. *Flower Artists of Kew*. London: Herbert Press, 1990.

Stiftung fur Botanik Library, 3 parts. London: Sotheby's, 1975.

Swinson, Arthur. *Frederick Sanders, the Orchid King*. London: Hodder and Stoughton, 1970.

Symonds, Mrs. John Addington. *Recollections of a Happy Life—Marianne North*. 2 vols. New York: Macmillan, 1893.

Synge, P. M. *R.H.S. Dictionary of Gardening*. London: Oxford University Press, 1956.

Twamley, Louisa Anne. *Our Wild Flowers*. London: Tilt & Bogue, 1853.

Van Ravenswaay, Charles. *Drawn from Nature*. Washington, D.C.: Smithsonian Institute, 1978.

Wakefield, Priscilla. *An Introduction to Botany*. London: Newberry, Darton and Harvey, 1796.

Walpole, Michael. *Natural History Illustration, 1485-1968*. Loughborough Technical College, 1969.

Wilkinson, Lady. *Weeds and Wild Flowers*. London: John Van Voorst, 1858.

Wirt, Mrs. E. W. *Flora's Dictionary*. Baltimore: Lucas Bros., 1855.

CATALOGS

Art of Botanical Illustration, The. Bryn Mawr: Bryn Mawr College Library, 1973.

Catalogue of the Natural History Drawings. Commissioned by Joseph Banks On the Endeavour Voyage 1768-1771. Westport, CT: Meckler Publishing in association with British Museum, 1984-1986.

Focus, The Flower in Art. Milwaukee: Milwaukee Art Museum, 1986.

Flowers in Books and Drawings c. 940-1840. New York: Pierpont Morgan Library, 1980.

Getscher, Dr. Robert H. *A Garden of Prints.* Cincinnati: Fine Art Gallery, John Carroll University, 1980.

Grant, N. H. *Flower Painting Through Four Centuries: A Descriptive Catalogue of the Collection Formed by Major the Honorable Henry Rogers Broughton.* Leigh-on-Sea, Essex, England: n.d.

Holmgren, Noel H., and Bobbi Angell. *Botanical Illustrations: Preparation for Publication.* Bronx: New York Botanical Garden, 1986.

Hunt Institute for Botanical Documentation. *The Hunt Botanical Catalogue.* vol. 1, "Printed Books 1477-1700," compiled by Jane Quimby; vol. 2, part 1, "Printed Books 1701-1800," part 2, "Introduction to Printed Books 1701-1800," compiled by Allan Stephenson. Pittsburgh: 1958 (vol. 1), 1961 (vol. 2).

———. *A Catalogue of Redouteana.* Pittsburgh: 1963.

———. *Catalogue of an Exhibition of Contemporary Botanical Art and Illustration.* April 6 to September 1, 1964. Pittsburgh: 1964.

———. *A Selection of Twentieth Century Botanical Art and Illustration.* Compiled by George H. M. Lawrence. Pittsburgh: XI International Botanical Congress, August 1969.

———. *Biographical Dictionary of Botanists Represented in the Hunt Institute Portrait Collection.* Boston: Hall, 1972.

———. *Artists from the Royal Botanical Gardens,* Kew, by Gilbert Daniels, Pittsburgh: 1974.

———. *Fourth International Exhibition of Botanical Art and Illustration, Nov. 6, 1977-Mar. 31, 1978.* Compiled by Sally W. Secrist and N. Ann Howard; Introduction by John V. Brindle. Pittsburgh: 1977.

———. White, James Joseph. *Fifth International Exhibition of Botanical Art and Illustration, Apr. 11 to July 15, 1983.* Pittsburgh: 1983.

———. Brindle, John V., and James White. *Flora Portrayed.* Pittsburgh: 1985.

Plant Illustration Before 1850. Garden Club of America. New York: The Grolier Club, 1941.

Scrase, David. *Flowers of Three Centuries. One Hundred Drawings and Watercolors from the Broughton Collection.* Introduced by Michael Jaffe. Washington International Exhibitions Foundation, 1983-1984.

LANGUAGE OF FLOWERS BOOKS

Flora Domestica, or the Portable Flower Garden, by Miss Elizabeth Kent, London, 1823.

Flora Symbolica, by John Ingram, London, 1869.

Flora's Dictionary, by a Lady (Mrs. Elizabeth Washington Gamble Wirt), Baltimore, 1830.

Floral Emblems, by Henry Philips, London 1824.

Flora's Interpretor, or the American Book of Flowers and Sentiments, by Sarah J. Hale, Boston, 1832. (Also called *Book of Flowers.)*

Flora's Lexicon, by Catherine Waterman, Philadelphia, 1839.

Floral Gems, by Mrs. J. Thayer, Boston, 1846.

The Floral Offering, edited by Frances Osgood, Philadelphia, 1850.

The Floral Wreath, edited by John S. Adams, Boston, 1852.

The Flower Vase, by Sarah Edgerton, 1844.

The Lady's Book of Flowers and Poetry, edited by Lucy Hooper, New York, 1824.

Language and Poetry of Flowers, by Sarah Carter Edgarton, London, 1848.

Le Langage des Fleurs by Mme. Charlotte de La Tour (Mme. Louise Cortambert), Paris, 1819.

The Language of Flowers, by John Stowell Adams, New York, 1848.

The Language of Flowers, by Henrietta Dumont, Philadelphia, 1851.

The Language of Flowers, edited by Frederic Shoberl, American edition, Philadelphia, 1836.

The Language of Flowers, by Robert Tyas, London, 1810.

Life Among the Flowers, by Laura Greenwood, New York, 1880.

The Sentiments of Flowers, or Language of Flora, by Robert Tyas, London, 1842.

BIOGRAPHY CREDITS

Badger, C. M. "The Victorian Flower Lithographs," *Antiques Magazine*, Katherine McClintock, June 1946, p. 361-363.

Blackwell, Elizabeth. *English Female Artists*, E. C. Clayton, 1876, vol. 2.

Bury, Mrs. Edward. *Journal of the Society of National Historical Biographers*, Nora F. McMillan, 1968, vol. 5, p. 71-75.

Cooper, Susan. *Susan F. Cooper and the Plain Daughters of America*, Lucy Maddox, Johns Hopkins University Press, 1988.

D'Esmenard, Nathalie. *Flowers of Three Centuries*, International Exhibitions Foundations, Washington, D.C., 1983-1984.

Dietzsch, Margareta Barbara. *Flowers of Three Centuries*, International Exhibitions Foundations, Washington, D.C., 1983-1984.

Drake, S. A. *Asa Gray Letters*, vol. 1, 1893, p. 131.

Dyer, Lady Harriet Anne Thistleton. *Artists from the Royal Botanic Garden, Kew*, 1974, p. 62-63.

———. *Gardener's Chronicle*, vol. 19, no. 3080, January 5, 1946.

———. *Nature*, 1945, vol. 157, p. 186.

Dykes, Elsie Katherine. *Daily Mail*, May 26, 1933.

———. *Gardener's Chronicle*, June 10, 1933, vol. 1, p. 394, 407.

——— *Iris Yearbook*, 1933, p. 14-15.

Eaton, Mary. *The Art of Botany*, New York Botanical Garden, 1985.

Harrison, Mary. *English Female Artists*, E.C. Clayton, 1876, vol. 1, p. 411-415.

Hey, Mrs. John. *R.V. Taylor's Biographia Londonensis*, 1865, vol. 67, p. 371-372.

Knip, Henriette Geertruida. *Flowers of Three Centuries*, International Exhibitions Foundations, Washington, D.C., 1983-1984.

Lee, Sarah. *Botanical Macaconsica*, 1978, no. 6, p. 53-66

——— *Dictionary of National Biographers*.

———. *Gentleman's Magazine*, 1856, p. 653-654. (1736, p. 653-654?)

———. *Hardy's Selections from the Correspondence of George Johnston*, 1892.

Loudon, Jane. *Bonplandia*, 1858, vol. 6, p. 324-325.

———. *Cottage Gardener and Country Gentleman*, 1858, vol. 20, p. 248, 255-259.

———. *Dictionary of National Biographers*, vol. 12, p. 148.

———. *Gardener's Chronicle*, 1922, p. 368; 1923, p. 77, 110-111; 1946, p. 101-103; 1955, p. 222-223.

———. *Gardener's Magazine*, 1839, p. 88-90.

———. *Some 19th Century Gardeners*, 1951, p. 17, 39.

Maund, Miss. *Dictionary of National Biographers*, vol. 13, p. 91.

———. *Gardener's Magazine*, 1839, p. 91-92.

———. *Journal of Botany*, James Britten, 1918, p. 235-243; 1928, p. 184.

———. *Proceedings of the Linnean Society*, 1863-1864, p. 30-31.

Mee, Margaret. *Journal of the Bromeliad Society*, 1980, vol. 30, p. 253-255.

Meredith, (Twamley) Louisa Anne. P. Mennell in *Dictionary of Australian Biographies*, 1892, p. 320.

———. B. Smith in *European Vision and the South Pacific*, 1768-1850, London, Oxford University Press, p. 219-231, 290-295, 298, 301 (1985).

———. *Journal of the Proceedings of the Royal Australian Historical Society*, 1921, p. 215; 1929, p. 3-14.

Moser, Mary. *Flowers of Three Centuries*, International Exhibitions Foundations, Washington, D.C., 1983-1984.

Moriarty, Henrietta. *Journal of Botany*, James Britten, 1917, vol. 1, p. 52-54.

Murray, Catherine Theresa. *M.V. Matthew's History of the Royal Botanical Garden*, 1986, p. 123-124.

Pope, Clara. A. Graves in *Royal Society of the Arts*, 1906, vol. 6, p. 181.

———. *Art Union*, March 1839, p. 23.

———. *Country Life*, 1957, p. ?

———. *Dictionary of National Biographers*, vol. 46, p. 130.

———. *Journal of Botany*, 1918, vol. 7, p. 126-127.

———. *Journal of the Horticultural Society*, 1933, p. 325.

———. *Country Life*, 1967, p. 1246-1248.

———. *English Female Artists*, Clayton Tinsley, 1876, p. 401-402.

Pratt, Anne. *Dictionary of National Biographers*, June 1977,

vol. 16, p. 284-285.
———. *Country Life*, Margaret Graham, June 2,
1977, vol. 161, p. 1500-1501.
———. *Horticultural Cottage Gardener*, 1893, vol.
27, p. 102.
———. *Journal of Botany*, 1893, p. 288; 1894, p.
205-207.
———. *Taxonomic Literature*, 1983, vol. 4, p. 383-
384.
———. *Women's Penny Paper*, November 1889.
Smith, Matilda. *The Royal Botanic Gardens Kew
Bulletin of Miscellaneous Information*,
1920, p. 210; 1921, p. 317-318; 1922, p. 83;
1927, p. 135-139, p. 527 528
Sowerby, Catherine. *Gardener's Chronicle*, 1870.
Thayer, Emma Homan. *Biographical Dictionary of Rocky
Mountain Naturalists*, J & N Dunn Ewan, 1981.
Twamley, Louisa Anne. *Art, Science, Taste in Australia*,
Bernard W. Smith, p. 219-223.
Twining, Elizabeth. *Asa Gray Letters*, 1893, vol. 1, p. 131.
———. *Taxonomenclature Literature*, 1986, vol. 6, p. 559-560.
———. *Dictionary of National Biographers*, vol. 57, p. 388.
———. *Garden*, Royal Horticultural Society, March 1983, p.
115-117.
Wakefield, Priscilla. *Dictionary of National Biographers*, vol.
20, p. 455-456.
———. *Gentlemen's Magazine*, 1832, vol. 102, p. 650
———. *Gardener's Chronicle*, N. G. Fussell, September 23,
1950, p. 180-181.
Wilkinson, Lady Caroline Catherine. *Journal of Botany*, 1880,
p. 224; 1882, p. 159-160.
Wirt, E. W. *Virginia Historical Magazine*, Sarah Stetson,
October 1949, p. 379-389.
Withers, Augusta Innes. A. Graves in *Royal Society of Arts*,
1906, vol 8, p. 326-327.
———. *Country Life*, Audrey Le Livre, February 2, 1989, vol.
183, p. 66-69.
———. *Gardener's Magazine*, 1831, p. 95; 1834, p. 452.
———. *Journal of Botany*, 1918, p. 242.

INDEX

Page numbers in italics refer to illustrations.

Agapanthus, 148
Agave, 166
Andrews, James, *18*
anemone, *69, 151*
Aquilegia, 8, 78
Arbutus, 124, 181
aroid, *98*
Aubriet, Claude, 35

Badger, Clarissa W. Munger, 13, 58-59, 66-71, *69*
Baily, Florence, 48
Basseporte, Mademoiselle, 35, 166
Bateman, James, 45, 207
Bauer, Frances, 14
Bauer, Franz, 28
Bessa, Pancrace, 54, *55*
bindweed *(convolvulus), 163, 198*
Blackwell, Elizabeth, 45, 49, 72-75, *73, 74*
Blunt, Wilfred, 13, 140, 161-63, 166, 206
Botanic Garden (Maund), 77, 130, *130*
Botanist, 60, 77-78, *78*, 130, *130*, 170, *171*, 204, *207*
botany, 16-19, 58, 158
botany books, 41-45, 58, 60
Britten, James, 161
bromeliads, *98*
Brookshaw, George, *34*, 37
Brugmansia, 207
Buc'hoz, Pierre Joseph, 34
Burgoyne, Elizabeth, 60
Burnett, Francis Hodgson, 11
Bury, Priscilla Susan, 41-42, *41*, 60, *60*, 76-79, *77, 78*, 130, 170

cactus, *112-13, 176, 192*
Calandrinia, 93
camellia, *69*, 114, *152, 155*
Campion, Thomas, 12
cardinal flower, *89*
Catlow, Maria Agnes, 41, 80-85, *80, 83*
Cereus, night-blooming, *66*
Charlotte, Queen of England, 28, 151
Chase, Agnes, 59
Chorizema, 94
Christmas rose, *124*
chrysanthemum, *124*
Churchman, Ellen Mary, 137
Clark, William, *21*, 25
clematis, *169, 178, 208*
Columnea, 98
Cookson, Catherine Teresa, 41
Cooper, Susan Fenimore, 13, 46, 63, 86-89, *86, 89*
crowfoot, *91*
Curtis's Botanical Magazine, 14, *31*, 35, 96, *96, 116*, 117, 152, 165, *165*, 188, 204

daffodil, *15*, 32, *120, 151*
dahlia, *204*
daisy, 25, 32
d'Esmenard, Nathalie, 60, 114-15
Dianthus, 161, 169
Dickinson, Emily, 9, 58
Dietzsch, Margareta Barbara, 60, *60*
Drake, Miss S. A., 44, 45, 90-95, *91, 93, 94*, 207-8
Dumont, Henrietta, 26, 48
Dürer, Albrecht, 16
Dyer, Lady Harriet Anne Hooker Thiselton, 96-101, 165
Dykes, Elsie Katherine, 13, *44*, 45, 102-9, *103, 105*

Eaton, Mary Emily, 110-13, *111, 113*
Echeveria, 78
Edwards, John, 34
Ehret, George, 13, 14, 34
Emerson, Ralph Waldo, 41
Epacris, 212
Epidendrum, 93

Fitch, Walter H., 96, 165
florilegiums, 34-39
Fritillaria, 184
fuschia, *184, 203*

gentian, *120*
George III, King of England, 28, 151
Gerard, John, 16
Gloxinia speciosa, 204
Graff, Johann, 140-41
Grandville, Jean, *12, 52, 53*, 54
Gray, Asa, 93
Greenwood, Laura, 48

Hale, Sarah Josepha, 21, 48, 56, 58
Hardwicke, Robert, 14, 146
Harrison, Mary P., 116-17, *116*
Hastings, Lady Flora, 21
Havell, Robert, 77
heartsease *(viola), 24*
Heckle, A., 37, *37*
Hemans, Mrs., 28
hepatica, *120*
herbals, 16
Hey, Rebecca, *21*, 24-25, *24*, 49, 56
Hooker, Sir Joseph Dalton, 96, 165
Hooker, Sir William Jackson, 28, 96, 206
Hooper, Lucy, 48, 58, 65
hyacinth, 32, *151*

Ingram, John, 42-44
insects, 15, 140, *140*, 142-45, *181, 184*

iris, *96*, 102-3, *120, 151*
ivy, 24

Jacson, Maria Elizabeth, 41, 46
Johnson, Mrs. S. O., 48
jonquil, 54
Josephine, Empress of France, 31

Kent, Elizabeth, *49*
Kew Gardens, 28, 96-98, 164, 190, 206
Knip, Henriette Geertruida, 35, 118-19, *118*

language of flowers, 26, 32, 42, 46, 54-57, *203*
Lawrence, Mary, 37
Lee, Sarah, 13, 18, *18*
leopard's-bane, *74*
lily, 25, *184, 204*
Lindley, John, 44, 91-93, 123-24
Linnaeus, Carl, 16, 21, 58, 147
Loudon, John Claudius, 41, 120-28, 206-7
Luculia, 212
lupine, *124*

McIntosh, Charles, 44
McMillan, Nora, 77
magnolia, *44*
Malope, 124
marigold, 55
Martin, W., 66
Maund, Benjamin, 60, 77, *78*, 130, *130*, 170, *171*, 204, *207*
Maund, Misses, 13, *17*, 130-35, *130, 133*, 170
Mee, Margaret, 136-39, *137, 138*
Melastoma, 190
Merian, Maria Sibylla, 15, 60, 140-45, *140, 143*
Millay, Edna St. Vincent, 60
Miller, Thomas, 44, 58
Moriarty, Henrietta Maria, 13-14, 146-49, *146, 148*
morning glory, *175, 196*
Moser, Mary, 35, 150-51, *151*
mullein, *196*
Munson, Laura Gordon, 48
Murray, Lady Charlotte, 51

nasturtium, *128*
Nesbit, Ethel, 37
Nicholson, Mrs., *31*
Nicotiana, 161

orchid, *29*, 31, *31*, 77, 91, *93, 98, 116, 136, 166, 170, 171*, 207, *207*
Osgood, Frances S., 42, 48, 56

pansy, *24*, 31
passionflower, 25, *69, 190, 203*
peony, *73*

Pharbitis learu, 208
polyanthus, *120*
pondweeds, *166*
Pope, Clara Maria, 152-55, *152, 155*
poppy, *91, 128, 175*
Portulaca, 208
Pratt, Anne, 42, 49-51, 156-63, *157, 158, 161, 163*
primrose, 32
Protea, 96, 146, 181

Redouté, Pierre Joseph, 13, 31, 34, 35, 54, 114
Repton, Humphrey, 31
Roscoe, Mrs. Edward, 49
Roscoe, William, 41, 77
rose, 31, 54, 55, 114, *128, 184, 188*
rosemary, 21
Rousseau, J. J., 54, *54*

Sigourney, L. J., 48
Smith, Matilda, 13, 35, 164-67, *165, 166*
snowdrop, *120*
Sowerby, Charlotte Caroline, 13, 168-69, *169*
Sowerby, James, 14, 36, 169
Späendonck, Gerard van, 35, 118
Stanwood, Cordelia, 59
Stearn, William T., 60
strawberry, *91*

Taylor, Jane, *31*, 130, 170-73, *170, 171*
Thaxter, Celia, 46
Thayer, Emma Homan, 13, 59, *59*, 174-77, *175, 176*
thistle, *60*
Thornton, John, 34
Trichopilia tortilis, 208
trumpet creeper, *111*
tulip, *44, 69, 103-9, 151*
Twamley, Louisa Anne Meredith, 13, *33*, 49, 51, *51*, 56, 178-87, *178, 181, 182, 184*
Twining, Elizabeth, 13, *13*, 44, *44*, 188-93, *188, 190, 192*
Tyas, Robert, 55-56

Vallet, Pierre, 34
Victoria, Queen of England, 28, 117, 158, 208
viola (heartsease), *24*
violet, *21*, 32, *120*

Wakefield, Priscilla, 194-95, *194, 195*
Waterman, Catherine, 48, 56, 58
Watsonia, 146
Wilkinson, Lady Caroline Catherine, 1, 13, *15*, 16, 21, 25, 28, 34, 41, 196-99, *196*
Wirt, Mrs. E. W., 28, 200-203, 281, *201, 203*
Withers, Augusta Innes Baker, *29*, 44, 45, 130, 170, 204-13, *204, 207, 208, 212*
wood sorrel, *196*

Finis